ON-CAMERA FLASH

Techniques for Digital
Wedding and Portrait Photography

Neil van Niekerk

AMHERST MEDIA, INC. ■ BUFFALO, NY

All photographs by the author unless otherwise noted.

Published by:
Amherst Media, Inc.
P.O. Box 586
Buffalo, N.Y. 14226
Fax: 716-874-4508
www.AmherstMedia.com

Publisher: Craig Alesse
Senior Editor/Production Manager: Michelle Perkins
Assistant Editor: Barbara A. Lynch-Johnt
Editorial Assistance from: John S. Loder, Carey Ann Maines, Charles Schweizer

ISBN-13: 978-1-58428-258-7
Library of Congress Control Number: 2008942244
Printed in Korea.
10 9 8 7 6 5 4 3 2 1

Table of Contents

About the Author

Neil van Niekerk, originally from Johannesburg, South Africa, is a wedding and portrait photographer based in northern New Jersey. He graduated with a college degree in electronic engineering and worked as a television broadcast engineer in South Africa (while pursuing photography as a parallel career) before deciding to settle in the United States in 2000. Says Van Niekerk, "I love photography for a variety of reasons. The stimulation and excitement of responding to new situations satisfies both my analytical and creative sides, and I also truly love working with people. I get real pleasure from sharing the happiness with the people that I photograph and knowing that I'm creating images that will evoke wonderful memories for a lifetime." Van Niekerk's "Planet Neil" website (www.planetneil.com) has become a popular destination for photographers seeking information on the latest equipment and techniques. Visit www.neilvn.com to see more of Van Niekerk's photography.

Foreword

All photographers know that flash is so, well . . . complex, artificial, and downright un-arty, right? Available light rules! (Or does it? What do you do when the existing light is garbage?) In professional photography, the facts are often quite a bit different than what people say. There can be a significant divide between what we say and what we really mean. Here are a few translations:

1. I don't use flash because it's so unnatural.
Translation: I don't know how to use flash.

2. Off-camera strobe is too much hard work.
Translation: I don't care enough to bother.

3. My customers don't know the difference.
Translation: I don't care enough to bother.

Well, have I got news for you! After reading this book, you will know how to use flash to great effect. After all, you *do* care about your customers, and you *do* care about improving, refining, and defining your own work—regardless of your position in the greater photographic food chain (and, let's remind ourselves, that does include brides' uncles and friends in their first year of art school).

Of course, I really should have written: "After reading, studying, digesting, and thoroughly practicing the contents of this book . . ." Ladies and gentlemen, we live in times of great and wonderful technology that has changed our industry more in the last ten years than in the century before. We also live in the age of the quick fix—the "give it to me now" and "I don't do instructional books" mentality. Among many photographers, this has resulted in a lack of knowledge about the craft of lighting—and more importantly, how to sculpt lighting. The quick-fix attitude is making many of us into photographic jellyfish—and the "dumbing down" of things we need to really know about being professionals is making us dull and often oh-so-very similar.

All too often, we think the answer is just to buy that new lens, new background, or the generic "action set" that promises to turn our images into hero shots without any effort on our parts. But have you ever noticed that under the surface of *any* top photographer's photograph, there is an original capture with great light? So, if you want my simple advice is, here it is: *The answer is never the gear, it's always the light.*

Now more than ever, how well we *find* light and how well we *make* light helps to differentiate practicing, passionate, professionals from the Uncle Bobs with sophisticated camera gear. (It also helps to reveal that a wad of amateur 4x6 prints is *not* a great wedding gift!) Customers don't care about how much your gear cost, but they care very much that your work looks vastly superior to Uncle Bob's.

As a final comment I will say this. In this book, Neil van Niekerk has presented you with a collection of examples that show you how to sculpt light, add light, and modify it—all with readily available strobes. It's a fantastic book. But don't think this knowledge comes just with a quick read, and a glance at his lovely pictures. He has *not* mastered these techniques as the result of a "quick fix" from someone else before him; he learned them as a result of effort and a desire to make substantially better professional images. I encourage you to make the same effort in reading, studying, and practicing—for you, for your customers, and for the industry you love.

—**David A. Williams**
M.Photog., FRPS, ALPE
www.davidwilliams-heartworks.com

About The Material In This Book

In Stephen Hawking's *A Brief History of Time*, he mentions his editor telling him that for every mathematical equation he included in his book, the readership would be halved. Astonished and bewildered, Stephen used only one equation in the book: $E=mc^2$. Following on that precept, I have kept the number of technical diagrams to an absolute minimum . . . of one.

An Easy Approach

I have done my best to make the material in this book as intuitive as possible. Books on lighting and flash photography usually have a steep technical slant to them, with terminology that is confusing at the outset. So, here you won't find talk of lighting ratios and such but a presentation of material on flash photography in a manner that makes it easy to grasp. Fortunately, digital photography also offers us a huge benefit with the instant feedback we get from the image on the back of the camera's display. This immediacy is a powerful learning tool, especially where lighting is concerned.

I have attempted to present the subject in such a way that there will be more than a few "Aha! *Now* I get it!" moments. I hope to offer readers of this book a strong foothold into the ever-fascinating world of flash photography and lighting, and the means to achieve what they want to with their photography.

I have done my best to make the material in this book as intuitive as possible.

The Images

The photos in this book are mostly wedding images and environmental portraits. However, don't feel that this only relates to weddings. The techniques here are just as applicable for most fields of photography. It just happens that most of my photography work involves weddings, and it was easier for me to find illustrative examples from my already existing work.

Equipment

The material in this book assumes an understanding of how shutter speed, aperture, and choice of ISO interact. It is also assumed that the reader has a D-SLR (digital SLR) and a flashgun that mounts on top of the camera.

I own and use both Nikon and Canon systems. For the most part, therefore, the techniques here are not specific to one system and should be accessible to

anyone who owns a D-SLR and a hot-shoe mounted flashgun. (*Note:* Not many of the techniques in this book can be achieved with the camera's built-in pop-up flash; it simply isn't flexible enough.) In this book, I often freely interchange the Canon brand name "Speedlite" with the word "flashgun." Keep in mind that the techniques used here are equally valid with the Nikon brand "Speed-light" flashes.

Many of the images in the book were taken at fairly high ISO settings and wide apertures. With the more modern series of D-SLRs on the market, photographers can have ever-improving image quality at these higher ISOs, which allows results that weren't quite possible just a few years back.

Similarly, prime lenses with wide apertures, such as the 50mm f/1.4 and the 85mm f/1.8, will give photographers a better entry into low-light photography than a slow zoom lens with an f/5.6 maximum aperture. These lenses are quite affordable; therefore, settings such as the wide apertures that were used in the examples in this book are well within reach of any photographer—even those just starting out.

> The images here had very little to no Photoshop work done to them.

The camera and flash settings are shown for each image. However, you should be aware that some of the settings are very specifically chosen (and are explained as such in the text), while other settings have a certain flexibility in how they were chosen. Camera and flash settings are nearly always dependent on the specific lighting situation and environment. Therefore, the settings that are supplied with the images are meant to help illustrate the choices made, and not meant as absolute values for any given situation.

Abbreviations

There are only a few abbreviations used throughout the book:

> CTO—color temperature orange gel
> CTS—color temperature straw gel
> FEC—flash exposure compensation
> WB—white balance
> EV—exposure value (1 EV = 1 stop)

Postproduction

Finally, the images here had very little to no Photoshop work done to them. I did correct the white balance and fine-tune exposure and contrast for these photos as part of my general RAW workflow. (I also retouched skin blemishes on occasion.) The reason why the photos weren't enhanced in Photoshop is to show real results from these techniques with on-camera flash.

1. What We Want to Achieve

As photographers, we're always looking for perfect light. For most of us, however, the available light in the situations where we find ourselves is rarely perfect. This is especially true for those of us who photograph weddings or environmental portraits. So, while finding beautiful existing light is every photographer's ideal, it isn't always possible—and what existing light we *do* find isn't always the best way to light our subjects.

However, with some knowledge of how to manipulate flash, we can very often improve a scenario by enhancing (rather than overwhelming) the existing light. This allows us to create photographs that are pleasing to our eyes—and to our clients—even when the ambient light is less than perfect.

To create these natural-looking results with flash, one of the ideals that we'll be after is seamlessly blending the flash with the available light to the point where it isn't quite discernable whether flash was used or not. This might not always be possible, but we'll get the most pleasing results from our flashguns if that remains our goal.

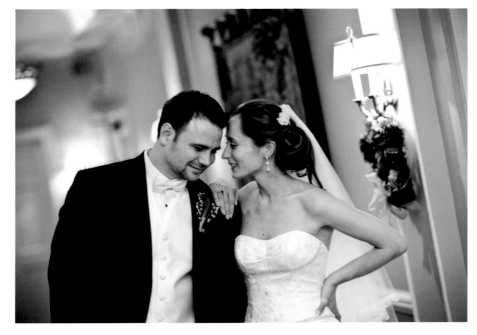

PLATE 1-1. Here, the flash was bounced behind me and gelled for tungsten light. (SETTINGS: $\frac{1}{125}$ second, f/1.8, 1000 ISO; FEC +0.6 EV)

Just as often, the available light is too low and too uneven. When this happens, we need to override the ambient light completely with flash to get the best results. In such cases, it will be obvious from the photographs that we used flash—but with some thought, and the careful application of some techniques, we can still get results that look great, with soft, directional light from our flash.

I hope by sharing my experiences and techniques, I can show you how to get results from your on-camera flashguns that look pleasing and even completely natural.

2. Looking At The Available Light

Even though this book is about the use of flash and how to blend flash with available light, it is also imperative that we recognize when the available light is just perfect. When the existing light is ideal, then there is simply no need for flash. For plates **2-1** and **2-2**, there was no need to use flash because the quality and direction of the light worked perfectly. There are times, however, when using flash makes a lot of sense—and this is what we're going to cover in the rest of the book.

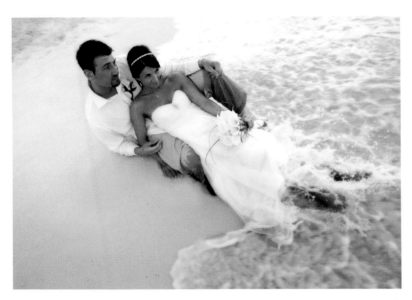

PLATE 2-1 (ABOVE). The early evening light on this Bahamian beach was soft and even. There was no necessity to add flash of any kind. (SETTINGS: $^1/_{160}$ second, f/4, 800 ISO)

PLATE 2-2 (RIGHT). Similarly, the interior lighting in this historic mansion was flattering and bright enough that I could take this portrait of the bride with no need for flash. (SETTINGS: $^1/_{320}$ second, f/2, 640 ISO)

3. A Few Essential Concepts

The Larger the Light Source, The Softer the Light

An inescapable principle in lighting is that the larger your light source (in relation to your subject), the softer the light is. This concept is the very heart of why we bounce flash: we are simply trying to create a larger light source when we bounce flash off of various surfaces.

The size of the front of the flash head is small, hence the direct light from it is quite harsh. If our light is direct and from the camera's viewpoint, the light will also be flat and unflattering. The moment we bounce flash off of a nearby surface (a wall, ceiling, or reflector) we have softer light, because we created a much larger light source. We now have to consider our light source to be the area we're bouncing our flash off, rather than the flashgun itself. Not only does bouncing flash create softer light, it can also make our light directional.

> The size of the front of the flash head is small, hence the direct light from it is quite harsh.

Direction, Intensity, and Color Balance

In our pursuit to seamlessly blend our flash lighting with available light, we need to be aware of the direction of our light, the intensity of our flash (*i.e.*, how much flash we're adding to the available light), and our color balance.

Direction. The direction from which we add our lighting will heavily dictate our results. With directional lighting, we mean light that comes in from an angle other than directly from the camera's viewpoint. Directional lighting will give us that interplay between light and shadow that gives shape and form to our subjects. It also reveals texture.

Intensity. How much flash to use (*i.e.*, the intensity of our flash) depends entirely on the existing lighting (also called the available light). The quality and amount of available light will be the basis on which we decide what to do with our flash lighting. For this reason, we'll touch on exposure metering tech-

PLATE 3-1. The flash exposure compensation was set quite high because of how the bride's dress influenced the metering of the TTL flash. (SETTINGS: $\frac{1}{125}$ second, f/4.5, 1000 ISO; FEC +2.0 EV)

PLATE 3-2 (TOP LEFT). The light from the flash enhanced the available light and opened up any shadows. The flash was bounced behind me to my left. (SETTINGS: 1/160 second, f/3.5, 1000 ISO; FEC 0 EV)

PLATE 3-3 (RIGHT). Since the background is much brighter than our little flower girl, it should not be allowed to affect our exposure metering. Here, fill flash was created by bouncing flash off of the ceiling of the porch the girl was standing under. (SETTINGS: 1/250 second, f/4.5, 200 ISO; FEC –2.0 EV)

PLATE 3-4. During the first dance, I followed the bride and groom, bouncing flash up and behind me. I had a Stofen Omnibounce (see chapter 9) on the flash so I could also throw some light forward from the camera; the ceilings were high and I didn't want to risk raccoon-like dark circles under their eyes. I had my flash gelled with a full CTO filter, which is why the background is pleasantly warm. If the videographer (seen in the background) had gotten close enough that his light became more pronounced, it would not have bothered me since it wouldn't have meant a change in color balance for me. (SETTINGS: 1/25 second, f/4, 1600 ISO; FEC +0.3 EV)

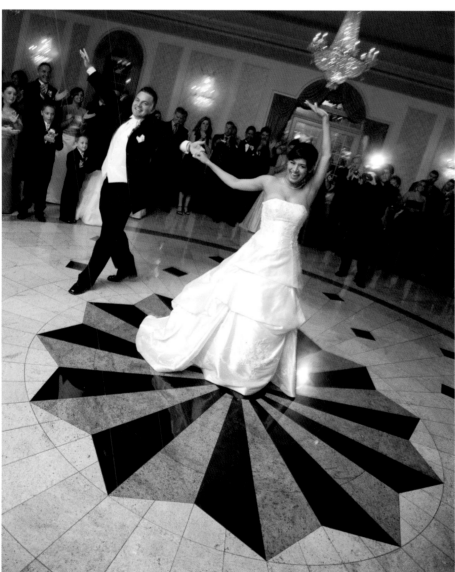

niques for available light, an important part of understanding and coming to grips with flash photography. We'll cover the decision process involved in choosing flash settings throughout the rest of this book.

Color Balance. Flash often has a tendency to give a blue tone to the colors in photographs, but this depends on the color balance of the scene we're photographing. When we're in a situation where the lighting is predominantly incandescent (tungsten) light, then the light from our flashguns can have a pronounced cold look. Conversely, if we correct to the flash's color balance, the background can be overly orange in color. We need to be aware of the color balance of our flash, since this is often the key to getting our flash to appear natural when we are photographing indoors.

Postproduction of the Image

While the approach here is to "get it right in camera," much of the photography done outside the studio is in less-than-perfectly-controlled situations. There is simply no photographer good enough to be able to set the exact exposure, correct white balance, and proper contrast and saturation for every image while busily shooting in constantly changing lighting conditions. As a result, most images will need some kind of postproduction work to look their best.

Also, since we will be using TTL or automatic flash metering of some kind, we might need to adjust for exposure inconsistencies in our postproduction workflow. Here, the RAW format gives us much more wiggle room than a JPG would. Ultimately, by shooting in the RAW format, you can only improve on the JPG you would've had.

One specific issue that will arise is that we will be bouncing flash off various surfaces that might be different colors. These could be painted walls, wood paneling, or even the trees or bushes nearby. This will introduce color casts to our images. These white-balance inaccuracies are easily corrected as part of a normal RAW workflow. This brings us to the next topic: white-balance settings.

White-Balance (WB) Settings

The simplest approach to getting a pleasant color balance is to set the camera to the closest appropriate white-balance setting (daylight, cloudy, etc.), then touch up this aspect of the image as part of your regular postproduction workflow. In this process, using a calibrated monitor will give you a neutral reference point. With a RAW workflow, it is easy to change the white-balance setting on multiple images, so this need not be a time-consuming process.

It is easier to finesse white balance in postprocessing than to find an exact setting while out shooting. Since we often bounce off non-white surfaces, the flash white-balance setting could appear too warm. Daylight white balance is often the best compromise here. The auto white-balance setting would work well enough with the more recent D-SLRs, but it might still be easier to keep entire sequences of images at the same white balance. Even with a slightly incorrect white-balance setting, it is faster to apply an identical adjustment to groups of images than to adjust the settings for each individual image.

Manual Flash *vs.* TTL/Auto Flash

With manual flash, our aperture and ISO choice will affect our exposure. With TTL (and Auto) flash, our aperture and ISO don't affect our exposures—as long as we stay within our equipment's capabilities. Similarly, with manual flash, the specific tonality of our subject doesn't affect our exposure. Neither should our composition. However with TTL and Auto flash, all of these affect our exposure and we need to compensate. Therefore, we'll spend a fair amount of time on exposure metering, TTL flash, and manual flash. So let's get started!

PLATES 3-5 AND 3-6. Photographing in this room, flash was bounced off non-white walls and woodwork, giving an overly warm color cast to the original image (top). Clicking on the white of the dress using the white-balance tool in the RAW editing program brought the color balance close to correct. Then, the image just needed a small touch-up in its white balance to make it a pleasing color balance (bottom). (SETTINGS: 1/40 second, f/4, 800 ISO; FEC +1.7 EV)

4. Notes on Choosing Equipment

Your choice of equipment can affect your technique. Here are three of the more important things you should consider.

Choosing a Flashgun

There is a wide range of flashguns available on the market, but two factors should heavily influence your decision. The first is the power of the flashgun, since this affects how well you can bounce flash (see section 3 for more on this). The second is whether the flashgun can rotate and swivel in all directions. Some flashguns are limited to swivelling upwards, meaning no left or right rotation is available. Others are limited in that they are only able to partially rotate in some directions.

Currently, the best choice of flash for Nikon is the SB-900; for Canon, it is the 580EX II. Both of these speedlights have top-of-the-range specifications and a myriad of options. Above all, however, they are powerful flashguns and can rotate 180 degrees to the left and to the right. This makes them stand out for flexibility of use.

Battery Packs

I would strongly recommend acquiring a battery pack of some kind for your flashgun. Battery packs help you to achieve more consistent exposures by providing a faster recycling time for your flashgun. This allows you to shoot faster than if you were relying on the recycling power of AA batteries alone.

> I would strongly recommend acquiring a battery pack of some kind for your flashgun.

With my Nikons, I use the Nikon SD-9 battery pack; with my Canons, I use the Canon CP-E4 battery pack. I use NiMH rechargeable batteries with both of these battery packs. These packs can be clipped to your camera strap, so you're not tethered to a pack clipped to your belt (as with the high-capacity battery packs we'll look at in a moment). If a flash bracket is used, the battery pack can be screwed onto the onto the vertical pillar of the flash bracket. This gives you more flexibility in being able to switch your camera from shoulder to shoulder, or even to set it down if you need to.

If I want more juice, or need to fire the strobe faster than those battery packs allow, there are high-capacity batteries, such as the Quantum 2x2 Turbo battery pack, that can be clipped onto your belt or carried on your shoulder.

A significant advantage of the smaller battery packs by Nikon and Canon is that they won't damage your speedlight when you rapidly fire your flash; a high-capacity battery pack might. It is possible to overheat your flashgun by rapid firing—and even to damage the front element and electronics from the intense heat. The Nikon and Canon battery packs will not allow you to fire your flash rapidly enough to create that amount of heat.

Flash Brackets

Anyone who has used direct flash indoors with the camera held in a vertical position has noticed the ugly, harsh, sideways shadows behind the subject. Rotating flash brackets help to address this issue. Placed between the camera and flash, they enable the flash to remain *above* the camera when flipping between vertical and horizontal photos. This, to some extent, reduces the shadow problem if you use direct flash or a flash modifier on your camera.

There are various makes of flash brackets. With some, you have to let go of the lens to flip the flash over with one hand. With more elegant designs, you rotate the actual camera with a deft flick of the hand holding the camera. There is so much variation between the different makes that it is worth checking them out for yourself.

Fortunately, digital photography technology has improved to the point where we now have cameras with fairly clean 1600 ISO settings, and very usable 3200 ISO settings. It is now ever more easy to get great results with bounce flash; having all the light from the flash be *indirect* can eliminate the shadow problem completely. With this technique, detailed in section 3, the need to use a flash bracket has been greatly reduced.

PLATE 4-1. It is now possible for me to get vertical images using on-camera flash and have no trace of sideways shadows. Because the light from the flash is bounced, it falls on the subject indirectly, creating no noticeable shadows. (SETTINGS: $^1\!/_{60}$ second, f/3.5, 1600 ISO; FEC 0 EV; full CTS gel on flash to balance with tungsten ambient lighting)

5. Exposure Metering

It is already assumed that you understand how shutter speeds, apertures, and ISO interrelate. This needs to become second nature in handling your camera, so you know that if you dial a control one way, you have to change another control the other way. For example, if you already have correct exposure and you increase your shutter speed by one stop (*e.g.*, $\frac{1}{125}$ second to $\frac{1}{250}$ second), you have to either open your aperture by one stop (*e.g.*, f/5.6 to f/4) or increase the ISO by one stop (*e.g.*, 200 ISO to 400 ISO). Of course, these need not be done in individual jumps but could be combinations of settings. For example, if you wanted to open up a stop, you could just as well change your aperture setting from f/5.6 to f/4.5 and your ISO from 200 to 250.

The moment we add flash, things change a little bit.

Of course, the moment we add flash, things change a little bit, but our best results are still achieved when we take the available lighting into account, one way or another. We might want to completely override poor lighting or low levels of ambient light with flash so that our only source of lighting is from flash, or we could have a scenario were we just need a soft touch of fill flash to even the contrast and bring out a bit of shadow detail. In between these two scenarios exists a wide variety of situations where we will have to continually adapt our approach and our technique to get the best results.

We should at all times be aware of the quality, direction, and color balance of our existing light and use this as a basis for our approach to using flash for any type of lighting situation. For this, we need to have a clear understanding of exposure metering.

Why Manual Exposure Mode?

Of all the exposure modes available on modern cameras, I would recommend that any photographer come to grips with shooting in the manual exposure mode. There are very specific reasons for this. The manual exposure mode offers us better:

- Accuracy of exposures
- Consistency of exposures
- Control over the depth of field
- Control over how subject/camera movement registers

None of the other exposure modes offer this kind of control or consistency. Unless the lighting conditions are changing rapidly (which might call for switching to the program or aperture-priority mode), shooting in the manual exposure mode makes for a more consistent series of images. If you're continually changing your compositions by switching between vertical and horizontal or wide and tight views, the only way to get consistent exposures is to shoot in manual. If you use an automatic setting (P, S, Av), your exposures will vary every time you change perspective, angle, or zoom. With greater consistency in your exposures, your digital workflow will be much easier, particularly if you shoot in the RAW format.

In the manual exposure mode, you have complete control over your settings. If something is wrong (this could be anything from poor exposure to too much motion blur), you are the one who needs to figure out why and how to improve on it. You decide; not the camera. When a photographer relies completely on automatic metering, their life becomes a quest for a camera that will do it all. When the camera's automatic metering inevitably fails (as it will under certain scenarios), the photographer becomes frustrated at having to second-guess the metering algorithms built into the camera and figure out how to work around them.

It might seem like a contradiction that much of this book is about TTL flash, which is an automatic metering mode. Yet, it makes sense in that TTL flash metering, when understood, really makes flash photography easier under a lot of conditions. Instead of second-guessing what the camera does in various metering modes under various conditions, and then adding TTL flash into the mix, we can gain much more control over how we use flash by *first* controlling our ambient exposure via the manual exposure mode.

This leads to an obvious question. Why would setting the aperture and shutter speed manually be different from using, say, the aperture priority mode and having the camera select the shutter speed? There are two reasons why it's best to not rely on the camera to choose the shutter speed:

1. Your camera's meter relies on the reflectivity of the subject and assumes it is middle gray. Even with matrix/evaluative metering, your camera can only guess at what you're trying to achieve.
2. If you use the program or aperture-priority mode with TTL flash as your main source of light, your camera will vary your shutter speed between shots, and the amount of ambient light recorded will, therefore, vary in turn.

These are the limitations of automatic metering, whether in-camera or with TTL flash. You have to understand how the lighter or darker tones within a

None of the other exposure modes offer this kind of control or consistency.

picture area will affect your meter—often when you don't want them to. You want a lighter tone to appear light in the final photo. You want darker tones to appear dark. But only if the image is an even mix of tonal values will you likely get an accurate meter reading in one of the automatic modes.

There are also specific reasons why using general exposure compensation with an automatic mode makes for inconsistent results. Using the exposure compensation dial on your camera is only useful when the area that you are metering is consistently darker or lighter than "average" (middle gray). If it is, you could simply dial in the exposure compensation to have the subject appear appropriately darker or lighter. But the moment that you vary your composition or zoom in and out, the metering can change—even though the lighting conditions remain the same, which implies that the settings should remain consistent.

With TTL flash, though, using flash exposure compensation *does* become necessary. This is because, as you change your composition, you also cause changes in the reflectivity and tonality of the scene that your camera's meter is reading. To compensate, you have to ride your TTL flash exposure compensation constantly. We will touch on this subject again, further on in the book.

Exposure Metering Techniques

To be able to creatively blend available light and flash, we need to take ambient light into account every time we use flash, even if flash is the dominant source of light. So, with this in mind, we'll initially touch on exposure metering for ambient light.

Metering Methods. In film days, a flash meter would be the only choice in metering for flash. For available light, the camera's built-in meter could also be used, but it would have to be interpreted to achieve consistent and accurate results. With digital, we have more tools available to us. Exposure metering can now be an iterative process of:

1. Using a hand-held incident light meter or flash meter
2. Using your camera's built-in meter
 —overall: metering off-average tones or large average areas
 —specific/spot-metering: placing the relevant white tones at 1.7 or 2 stops over
3. Checking the histogram (positioning the brightest relevant tone on the histogram)
4. Checking the blinking highlights display
5. Using the Sunny 16 rule (see page 24) when in bright daylight
6. Confirming the exposure by eye via the image on the LCD
7. Anticipating the optimal settings based on experience

In film days, a flash meter would be the only choice in metering for flash.

We can even employ a combination of these methods; if used with some thought, they should all lead toward the same exposure. For example, we can use the histogram in specific situations to accurately determine exposure. Ideally, this should coincide with a careful interpretation of our camera's light meter. This, in turn, should reveal an image on our camera's LCD that looks fairly close to what we're trying to achieve.

It is best not to be too dogmatic about a specific method. Instead, fluidly adapt the various methods depending on the situation. This could mean using a mix-and-match of different techniques, all designed to make sure we get optimum exposure for our images.

Metering Objectives. An understanding of the Zone System is invaluable in gaining a mastery of exposure metering. The specifics fall outside the scope of this book, but the Zone system is essentially a method that divides any scene into specific tones, from the brightest white to the deepest black tone. By establishing these, the photographer has very good control in rendering any scene with the full range of tones available.

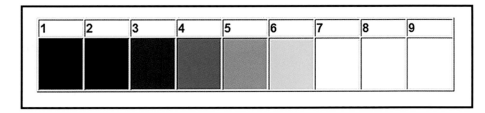

PLATE 5-1. The Zone System divides scenes into tones from blackest black to brightest white.

In a similar way, we can think of our scene (or subject) as containing a range of tones that we need to record with digital capture. We need to retain detail in our brightest relevant tone (close to pure white), and we also need to retain detail in the darkest relevant tones.

For example, if we aim our camera's built-in light meter at a bride in a white dress against a white wall, then shooting in the automatic mode, or simply zeroing our meter in the manual exposure mode, will lead us to an underexposed image; the camera will want to render the scene as middle gray, not white.

Similarly, for someone dressed in a black tuxedo against a dark wall, zeroing our camera's meter reading will give us an overexposed image; the camera will want to render the scene as middle gray, not black. We need to figure out where to place the bright and dark tones and expose accordingly.

Using a Hand-Held Incident-Light Meter. With an incident-light meter (which measures the light falling onto the meter), we know the light intensity—and, hence, our optimal exposure settings—regardless of the subject's tonality. Light metering techniques with a hand-held meter are only briefly mentioned here as one of the possible metering techniques. We won't go into detail, since the topic is more appropriately and thoroughly dealt with in other books.

Using And Interpreting the Camera's Built-In Meter. It is essential to know that any light meter will provide a reading designed to yield a middle-gray

tonality. This works perfectly for an incident light meter that measures the amount light falling on the subject. However, with a light meter that reads reflected light (such as an in-camera light meter), we will have to interpret our light-meter reading in terms of the subject/scene tones.

Looking specifically at the example of a bride in a white dress, the brightest relevant tone that we need to capture is the dress itself. If we can successfully place that tone, then every other tone (skin color, flowers, and other details) will fall into place. If we zero our camera's built-in light meter while pointing it at the dress (and metering only off the dress), then we will have a dress that appears gray. This is because of the meter's inherent design to render everything as middle gray. We therefore need to "force" the white dress to appear as white to the camera's meter.

We can do this by placing our meter reading 1.7 to 2 stops over what the camera says. This amount is based on practical experience and isn't a scientifically calculated value. The exact amount you need to bias your meter reading will depend on the specific camera make and model you are using, as each camera's metering system is slightly different. This is something you will have to figure out through your own tests with your own equipment.

By pointing our camera at the brightest relevant tone (the white dress), then changing our aperture/shutter speed/ISO combination so that our in-camera meter shows 1.7 or 2 stops over the zero mark (five or six bars on most camera displays), we are telling our camera that we want white to appear as white.

This method of metering is best illustrated by checking your own camera. Photograph anything that is predominantly white, then compare an image made using an automatic setting to one where you meter specifically for the white tone as described above. This exercise can be as simple as draping a white shirt over a chair, then practicing rendering the white shirt as a bright white tone.

We will go over this more thoroughly in a practical example as soon as we've covered some other techniques—and, specifically, how to use the histogram to evaluate your results.

Using the Histogram to Determine Exposure. Histograms display the relative levels of the darker to brighter tones in an image. As the histogram stands, it isn't of much direct use. Because the tonality of each scene will dictate what the histogram shows, it does not provide a direct indication of whether the exposure is *correct*. Some will say that a "correct" histogram should have an even bell-shaped curve, but this is too simplistic. A light-toned subject against a white wall will show a much different histogram than a dark-toned subject against a dark wall—even though the exposure might be correct in both instances. Additionally, it isn't of much use looking at the histogram to determine exposure if there are bright patches of sky or highly reflective surfaces in the scene we photographed. This will change the histogram display, making it seem the image is overexposed when, it fact, we might well have the correct exposure.

The tonality of each scene will dictate what the histogram shows . . .

However, there is still a way to use the histogram to determine correct exposure. Essentially, there is one thing of consequence to us: the right-hand edge of the histogram display. In fairly simple terms, the right-hand edge of the histogram shows us the limit of what our sensor can capture. Anything past the right edge *will not* be recorded; everything to the left of this edge (which is what we see as the histogram shape) *will* be recorded.

This explanation is fairly simple and doesn't take into account the latitude we have with the RAW format, or the valid technique of "exposing to the right," but this approach will allow us to use the histogram in a practical way. (*Note:* "Exposing to the right" is a method where we intentionally overexpose our images by a certain amount—say +0.7 EV. This overexposure is then corrected as part of RAW postproduction. We rely on the latitude of the RAW file, so that the overexposure, to an extent, has little or no effect on the final image. The main motive for using this technique is that, in bringing the overall exposure down to correct levels, we also bring down the digital noise, which mainly resides in the shadow areas of the image.)

The right-hand edge of the histogram will show us where the brightest relevant tone should be. The word *relevant* needs to be stressed. For example, if our subject is wearing a white shirt or dress, then we could be expected to capture detail in the shirt or dress. With this in mind, using the histogram to quickly determine exposure depends on pointing the camera to an area that contains the white shirt/dress and no other bright areas. That's when the most right-hand point on the histogram will show the white areas of our subject. Once we place that white tone correctly on the histogram, all the other tones will fall into place—whether skin tones, clothes, or surroundings. We do this by taking a close-up view of the relevant brightest tone and ensuring that this is near (but not against) the right-hand edge of the histogram. This exposure value can then be locked by using the manual exposure mode. Once this is done, all of the images taken under the same lighting will be correctly exposed. I've found this method to be so consistent that I rarely use my flash meter, even when using studio strobes.

The way that the different camera manufacturers currently display the histogram varies—and the way the histogram will be displayed in future models might well vary, too. Fortunately, this approach to using the histogram should remain valid, even if it might need some interpreting from camera model to camera model.

Using the histogram to determine exposure (not merely confirm exposure) requires a consistent light source, such as ambient light or studio strobes. This allows us to take a series of images, check the histogram, then make a decision as to what combination of settings will give us the best exposure. We can only *confirm* TTL exposure this way, not use it to determine the exposure like we would be able to with studio lighting or available light.

In fairly simple terms, the right-hand edge of the histogram shows us the limit of what our sensor can capture.

In plate **5-2**, you can see what Canon's histogram looks like on the 1D Mark II. I have found that I will get the best exposure if the brightest relevant area has the edge of the histogram appear about a third of the way in from the edge of that display. It would seem that this varies a little between the various Canon D-SLR models, so it will be necessary for anyone who wants to use this method of calculating correct exposure to interpret and apply this idea to the specific camera being used.

If the image is overexposed, the kind of spike seen at the right-hand edge of the next image (plate **5-3**) will start to appear. With Canon D-SLRs (in my experience), the highlights warning won't blink yet (see page 23), but the image *may* appear too bright.

PLATE 5-2. The histogram on a Canon 1D Mark II.

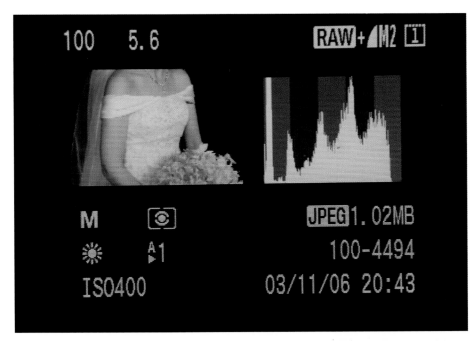

PLATE 5-3. A spike at the right-hand edge of the histogram indicates the image is overexposed.

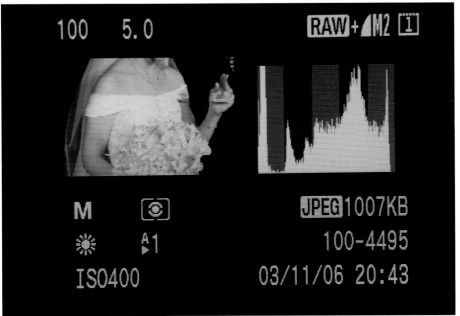

As seen in plate **5-4**, the Nikon histogram looks slightly different. In my experience, I get an optimally exposed image if I place the edge of the histogram (for the brightest relevant tone) just shy of the corner of the histogram display. (There's that term "relevant" again. It's an important distinction.)

Plate **5-5** is the same image, but ⅔ stop overexposed. You can see the spike on the right-hand side of the histogram. It looks different than the spike on the Canon histogram.

In the next histogram (plate **5-6**), we see underexposure on a Nikon histogram. (The same would be true for the Canon histogram.) Even though we'd be able to pull up the exposure in postprocessing, doing so would also lift the shadow areas (the left-hand side of the histogram), making any noise more prominent. By exposing correctly, not underexposing, we'll be able to better control the appearance of noise.

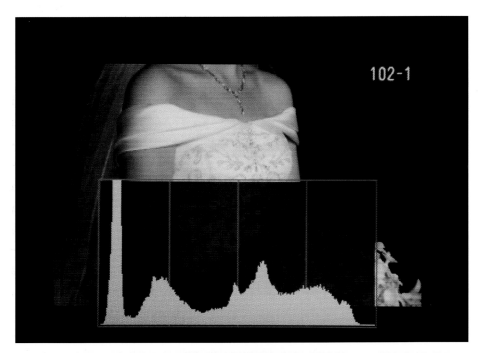

PLATE 5-4. The histogram for an image on a Nikon camera.

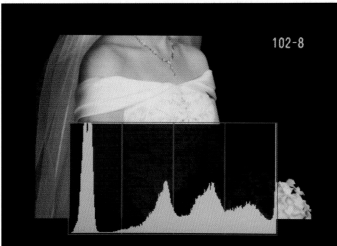

PLATE 5-5. The histogram for an overexposed image on the Nikon.

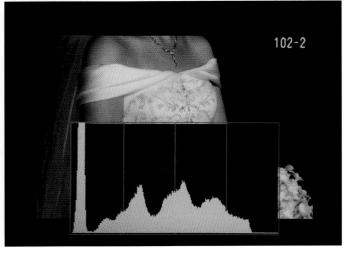

PLATE 5-6. The histogram for an underexposed image on the Nikon.

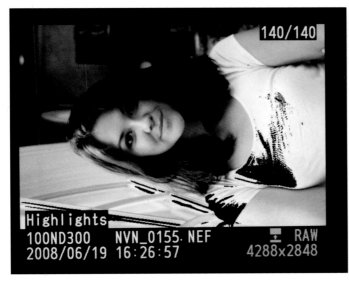

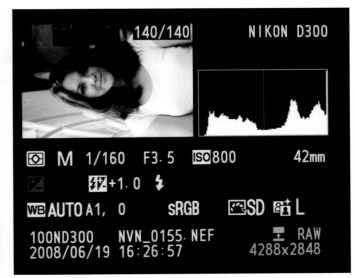

PLATE 5-7. With the current Nikon D-SLRs, the blinking highlights display shows immediately when overexposure occurs.

PLATE 5-8. Here, the histogram is clipping on the right-hand side.

Remember: this exposure method only works if we're using ambient light or manual flash in a fixed position. If we had our flash on our cameras and were moving about, then our flash-to-subject distance would vary as we moved and we wouldn't be able to use the histogram to determine exposure over a series of images. Instead, the histogram would offer a way to confirm the overall exposure with accuracy similar to that of using a flash meter. It is entirely possible to forego the use of a flash meter when using this histogram technique with a manual flash setup, such as on location or in the studio. (*Note:* Calculating lighting ratios, however, is still best left to a careful approach with a flash meter.)

The Blinking Highlights Display. This method can provide a quick confirmation of correct exposure when we are dealing with a subject that contains bright enough tones (such as white). This function is also highly dependent on the specific camera make and model.

On the current Nikon D-SLRs, the blinking highlights display shows immediately when overexposure occurs (plate **5-7**). Clipping shows at the right edge of the histogram (as in this image, where the overexposed areas of her shirt show flashing black). If we are photographing a bride in a white dress, it is entirely possible with a Nikon D-SLR to pull back the exposure a click or two on the shutter speed or aperture dial until the blinking highlight display doesn't show. This can be a quick method of adjusting exposure on the run without having to pause to interpret the histogram.

In plate **5-8** you can clearly see how the histogram is clipping on the right-hand side. This will show up as blinking highlights on the current Nikon D-SLRs. You have to note, however, that the subject's white shirt is the brightest part of this image. If there were sky areas or clouds in the picture, those would appear as the clipped part of the histogram and should not be used as an indication that there is necessarily overexposure.

This can be a quick method of adjusting exposure on the run . . .

On the current Canon D-SLRs (plate **5-9**), the blinking highlights do not appear as immediately as on the Nikon D-SLRs when there is overexposure. This means that pulling back from the blinking highlights to get correct exposure isn't as directly obvious as with the Nikon D-SLRs. As you can see here, the histogram isn't clipping yet, but there are blinking highlights. The blinking highlights remain a very useful alert that we have overexposure if part of our relevant tones are blowing out.

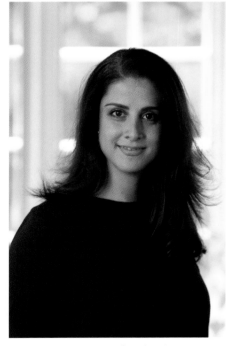

Having blown-out highlights is not necessarily a problem. In portraits, if some part of the background blows out, it is less of a concern than if some detail of your subject is blown out. In plates **5-10** and **5-11**, part of the background shows blinking highlights. However, correct exposure for skin tones is the main consideration. The background can blow out without much worry. In this instance, correct exposure might be more easily based on the LCD preview image itself than the blinking highlights display or the histogram.

PLATE 5-9. On the current Canon D-SLRs, the blinking highlights do not appear as immediately as on the Nikon D-SLRs when there is overexposure.

The Sunny 16 Rule. A basic exposure rule, which was used a lot when shooting film, is that bright sunlight is correctly exposed at f/16 when the shut-

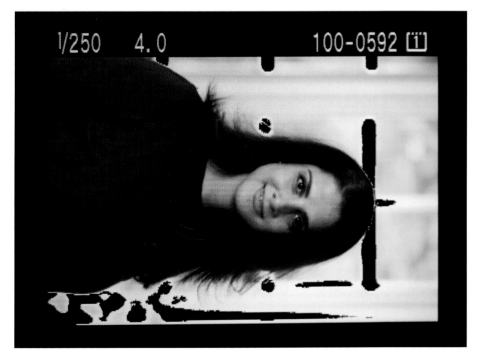

PLATES 5-10 AND 5-11. Here, part of the background shows blinking highlights, but getting the correct exposure for the skin tones is the main consideration.

ter speed is the closest inverse of the ISO. So, at f/16, if your ISO was set to 100, a shutter speed of around $\frac{1}{100}$ second would give you the right exposure.

This can be expanded for various shutter speed/aperture combinations, as shown below. We could set any combination here and our photographs should look exactly the same, in terms of exposure and brightness.

SHUTTER SPEED	APERTURE	ISO SETTING
$\frac{1}{2000}$ second	f/4	100 ISO
$\frac{1}{1000}$ second	f/5.6	100 ISO
$\frac{1}{500}$ second	f/8	100 ISO
$\frac{1}{250}$ second	f/11	100 ISO
$\frac{1}{125}$ second	f/16	100 ISO
$\frac{1}{60}$ second	f/22	100 ISO

The Sunny 16 rule generally holds true and can be used as a quick guide to our settings. For example, if we were photographing indoors and then stepped outside, we could immediately set our cameras fairly closely to settings that would be accurate and well within the parameter of what we could fine-tune with a RAW file.

I use the Sunny 16 rule as a base setting whenever I am outside, but I use a specific variation of the settings. On most modern D-SLRs, the maximum flash-sync speed is around $\frac{1}{250}$ second. (*Note:* The range varies depending on the model of the camera, but is typically between $\frac{1}{200}$ and $\frac{1}{500}$ second. Be sure to check your camera's manual for the exact setting for your camera. For simplicity of explanation, however, we'll keep the discussion centered around a maximum flash-sync speed of $\frac{1}{250}$ second.) So, whenever I step outside into bright sunlight, I set my camera to $\frac{1}{250}$ second at f/11 and 100 ISO. This is usually correct within about $\frac{1}{3}$ stop. Again, these settings can vary between camera makes and models, so the specific settings should be something that you confirm for yourself. For example, the Nikon D200 will give better exposure at $\frac{1}{250}$ second at f/10 and 100 ISO in bright sun.

There is a specific reason why I choose $\frac{1}{250}$ second as my base setting whenever I work outside in bright light (or have to balance a subject in shade against a bright background). We'll touch on this more specifically later on in the book when we talk about the flash-sync speed.

Confirmation of Exposure Accuracy via the LCD Image. Previously, the angle at which a D-SLR's LCD display was viewed heavily influenced how bright the image appeared. This made the image on the LCD nearly useless in helping to determine exposure. More recent D-SLRs have LCD previews that are quite accurate renditions of the photo that was taken. Therefore, the image on the LCD can now be used to confirm accurate exposure with much more reliability. In fact, many of the techniques described later in this book rely on con-

I use the Sunny 16 rule as a base setting whenever I am outside . . .

firmation of what the image looks like on the LCD, and then adjusting our technique accordingly.

Anticipating Our Settings. Our choice of shutter speed, aperture, and ISO combinations should be based on three factors:

1. Setting the lowest possible ISO that we can (in order to get the best image quality)
2. Maintaining a shutter speed that will stop camera shake and freeze as much of the action as we want
3. Maintaining an aperture that is sufficiently shallow or deep to suit our artistic intentions

Here, common sense should guide us closer to appropriate settings. In bright light outdoors, we'll be using 100 ISO. In dim interiors we will be aiming toward a higher ISO (such as 800 ISO), while using a wider aperture and slower shutter speed (a shutter speed like $\frac{1}{4000}$ second just doesn't make sense indoors).

It is important that we start to anticipate things. For example, if I am shooting indoors where my flash is my dominant light source, I'll most likely be shooting at 400 ISO, 800 ISO, or even higher. I'll also be using a medium or slow shutter speed to get some ambient light in—say around $\frac{1}{60}$ second or so. I will also be more likely to use wider apertures to capture more ambient light. It really depends on the scenario, however.

A flashgun like the Nikon SB-800 Speedlight will probably be set to TTL (and not TTL BL), since the flashgun will be the dominant light source and probably not just used as fill flash. (*Note:* TTL BL is designed to give optimum fill flash.) Flash compensation will most likely be around the zero mark, or maybe +0.3 flash exposure compensation as the default.

With Canon, I find that when my flash is the main source of light, that using the Average TTL flash metering setting gives me the most predictable results. But when I need to use the Canon flash for fill only, then I get more subtle results with the flash metering set to Evaluative flash metering. These settings are available through the camera and flash menus.

Moving from the dimly lit indoors to bright light outside, I do three things as a matter of course as I step through the doorway:

1. I dial down to my lowest ISO.
2. I dial up to my highest flash-sync speed.
3. I set my aperture to an approximate value, which I will then fine-tune using any of the previous methods to get to correct exposure.

There is a specific reason why I gravitate toward my maximum flash-sync speed. There's a certain sweet spot there in terms of getting the maximum range from

Here, common sense should guide us closer to appropriate settings.

your strobe. This is quite useful when you need to balance a subject in shadow against a brightly lit background, for example. We'll cover this in detail later in the book.

If I had been shooting indoors at f/2.8 and f/4, then I will need a smaller aperture outside. For 100 ISO and a shutter speed of ½₂₅₀ second, an appropriate aperture might be something like f/11 outside. So I'll set f/11, fire off a test shot or two at a general scene, quickly check the histogram and blinking highlights, and then fine-tune my exposure. All of this has to happen in a few seconds; the settings must be adjusted fluidly without stopping. Then we're prepared and ready to shoot. (*Note:* Quite often I am not aware of the specific value of my settings—I just count clicks. For example, the difference between settings like f/4 and f/4.5 is incremental; it's similar for shutter speeds and ISO settings. Therefore, if the image on the LCD seems like it needs brightening (*i.e.,* more exposure), then I could simply click either the shutter speed, aperture, or ISO settings by one or even two clicks without checking the exact value.)

Overcast days will mean a different aperture than the f/11 setting I choose for bright days, but 100 ISO and ½₂₅₀ second for the shutter speed is always my starting point for Canon D-SLRs. If it is heavily overcast, I'll go to 200 ISO, but I will often try to keep close to the maximum flash-sync speed if possible.

With Nikon D-SLRs, a good starting point might be around ½₂₅₀ second at f/10 and 100 ISO. This is because there is a difference in the sensitivity of the sensors of the various camera manufacturers. (Some of the newer Nikon D-SLRs have a base ISO of 200; adjust the combination of settings accordingly.)

Moving from an indoor setting, as we step outside we can instinctively set our camera's controls to be close to where we need them to be—with no fumbling for settings. We're ready because we anticipate what we're going to need.

Tying it All Together

In the following series of images, we're going to tie together a few of these techniques. We will be juggling three settings: shutter speed, aperture, and ISO. For a portrait like this, an aperture of f/4 or wider is preferable, to minimize the depth of field. A fast enough shutter speed to yield sharp handheld images is also a strong consideration. Additionally, we have to choose an ISO that will still produce a flattering portrait. We have to balance our settings, but there is some leeway here in the specific values. This means that one photographer will have settings that vary from what another photographer might have chosen—but both will still be correct.

_Looking at the initial image of our model (plate **5-12**), we can see that, depending on our composition, we could have large areas of darker tones or brighter areas from outside—all of which would influence our camera's light meter reading. Yet, there is a consistent amount of light falling onto her face

We have to balance our settings, but there is some leeway here in the specific values.

and, ideally, we need to meter for that. (*Note:* Even though using the Program mode might have gotten us a correct exposure, it is of much more value to us to understand how to make our own exposure decisions. We will need these skills in situations with more problematic lighting.)

In this scenario we're not particularly interested in getting detail in the outside areas, we just want to nail the skin tones. We do so by exposing correctly for the brightest relevant tones: her blouse or dress. We can move in close, or zoom in close, or use the camera's spotmeter to meter only for the white area. However, if we simply zero our camera's light meter, we'll get an exposure setting that records the white as middle gray (this would be the same as if we'd used an automatic metering mode). Additionally, note that the white part of her blouse isn't evenly lit—there might even be a full stop of difference in exposure from left to right as the light from the window falls off to the inside.

Plates **5-15** and **5-16** show how the histogram looks, centered toward the middle, when the camera is pointed at a purely white subject while in an automatic metering mode. The white isn't white, it's dull gray. Because we want the white dress/blouse to appear white, we need to somehow shift that tone up to where it belongs. We can do this by metering for the white, then increasing our exposure by around 1.7 stops with Canon D-SLRs or about 2 stops with Nikon D-SLRs (again, this can vary from camera to camera).

It is possible to make incremental changes to the exposure settings by counting the clicks. To increase the exposure by 2 stops, we can count six clicks in total on the shutter, aperture, or even ISO dial. Similarly, an increase of 1.7 stops would be the same as five clicks up. The metering display will also now show that we are five or six marks over the zero mark. (*Note:* Check your camera for the specifics of the metering display; this will differ from camera to camera.)

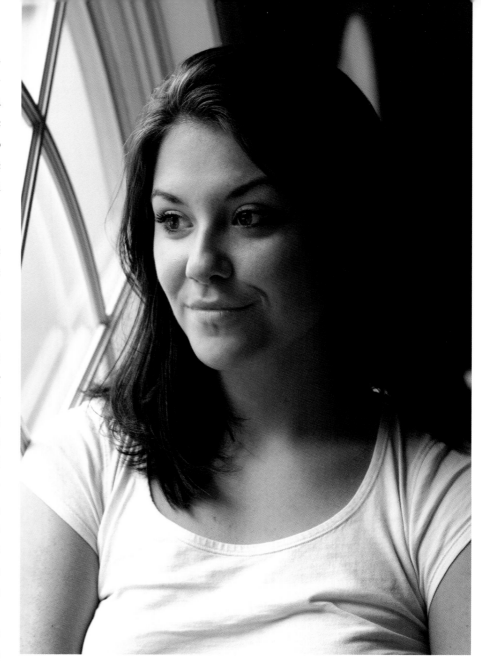

PLATE 5-12. For this classic window-lit portrait, the easiest way to get the correct exposure would be to use a handheld incident light meter and measure the amount of light falling onto our subject. With digital cameras, though, we can just as easily use the histogram and selective metering with our camera's light meter to get to the same place.

Having made this adjustment, we can double-check our exposure against the histogram. If we're on the right track here, the histogram should confirm that we have a correct exposure; it should show that the white area (brightest relevant tone) is close to the edge of the histogram. With Nikon cameras, we can easily confirm this via the blinking highlights display (this is enabled in your camera's menu). If the image shows blinking highlights on the white part of the shirt, then we have overexposure. We aren't concerned if the very edge of the shirt shows blinking highlights; this kind of overexposure on the very rim of the clothing isn't necessarily bad. However, if larger parts of the shirt show blinking highlights, we need to pull down our exposure by one click (a third of a stop) on either the shutter speed, aperture, or ISO until another test shot shows that there are no blinking highlights. When we reach this point, the histogram should confirm what we're seeing in terms of there being no blinking high-

PLATE 5-13 (LEFT). We first need to meter for the white of her blouse, the brightest relevant tone.

PLATE 5-14 (RIGHT). Here's an example of what we'd get if we used an automatic metering mode to take a test shot of the white. The camera's metering system would render the white as middle gray. The effect would be very similar if we had just zeroed our camera's light meter display in the manual metering mode.

PLATES 5-15 AND 5-16. This is how your histogram would look if your camera was pointed toward a white object while in an automatic metering mode.

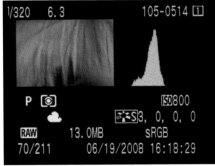
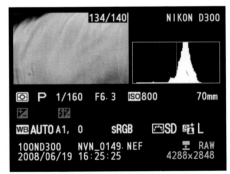

PLATES 5-17 AND 5-18. Increasing the exposure makes the white record more accurately.

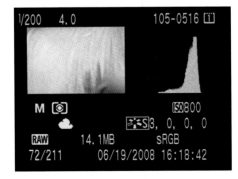
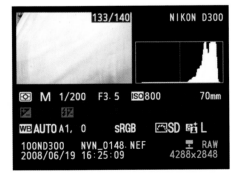

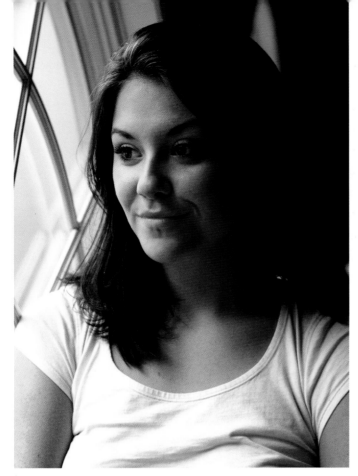

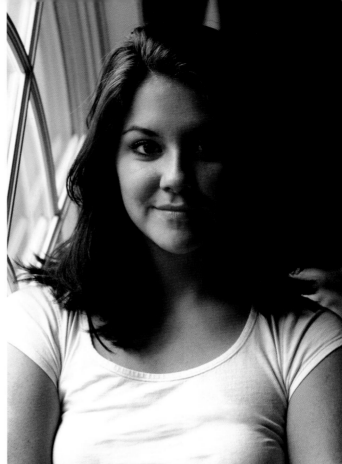

lights. This should also coincide with our meter reading in our camera telling us that we're exposing for the white at +1.7 stops (or perhaps even +2 stops).

It is important to realize we are not in fact overexposing, but exposing *correctly*. Increasing our exposure by 1.7 stops might seem like overexposure, but this is what we need to do to have the white of her shirt correctly exposed as white. We now have our basic exposure correctly metered. The whites are not blowing out and are at an optimum value on our histogram—but we still have to be flexible on this. This exposure setting is a starting point; we must be prepared to fluidly change our settings to achieve the optimum results.

In the same scenario, if the subject wasn't wearing white, you could meter off her skin tone then add to or subtract from the exposure indicated by the camera's spot meter. This method is, however, dependent on you estimating how light or dark the subject's skin is. Because the model in this sequence has a light complexion, I might have added +1 EV or +0.7 EV; with a subject who had a very dark complexion, I might even have used a negative EV value. Obviously, this makes exposure metering more of a judgment call than a factual determination of correct exposure. Even if your estimate is a little off, though, metering this way will still be a huge advantage in getting a faster workflow; it will give you consistency between the photos in any particular series of images.

Continuing on, if our model now looks toward the camera (as in the plate **5-20**), the result is an interesting portrait that is high in contrast. The side of her face closest to the window is correctly exposed, but the area away from the win-

PLATE 5-19 (LEFT). Here is our beautifully exposed window-light portrait again. Correct exposure metering, paired with a combination of selective metering and checking the histogram, allowed us to produce these results. (SETTINGS: ½00 second, f/4, 500 ISO; no flash)

PLATE 5-20 (RIGHT). Having the model look toward the camera results in higher contrast on her face. (SETTINGS: ½00 second, f/4, 500 ISO; no flash)

dow is perhaps too dark. In a sequence of photographs of a model I would certainly keep these, but I would also want to give a more flattering portrait by reducing the contrast.

This contrast reduction can be achieved by bouncing flash into the room to lift the shadow areas. The next series of images (plates **5-21** to **5-24**) shows the effect of this technique, bouncing flash into the room—off part of the ceiling and various random objects in the room. It is very important that the flash head is turned so that the subject cannot see any part of the flashtube. Otherwise, there will be direct light on the subject from the flash. In these images, you see the effect of adding flash in progressive steps at –3 EV, –2 EV, –1 EV, and 0 EV.

> This contrast reduction can be achieved by bouncing flash into the room . . .

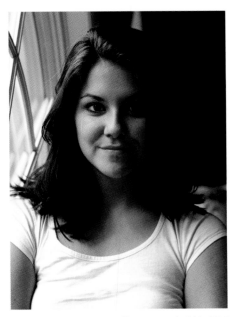

PLATE 5-21. (SETTINGS: ¹/₂₀₀ second, f/4, 500 ISO; FEC –3 EV)

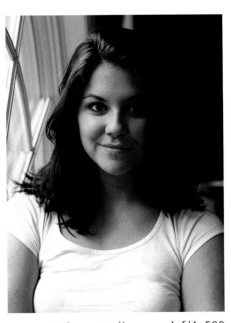

PLATE 5-22. (SETTINGS: ¹/₂₀₀ second, f/4, 500 ISO; FEC –2 EV)

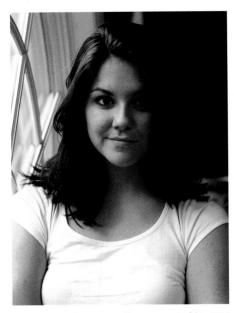

PLATE 5-23. (SETTINGS: ¹/₂₀₀ second, f/4, 500 ISO; FEC –1 EV)

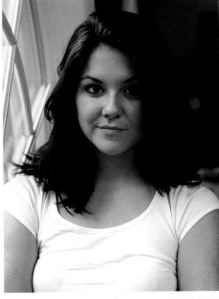

PLATE 5-24. (SETTINGS: ¹/₂₀₀ second, f/4, 500 ISO; FEC 0 EV)

This is a technical exercise I would really recommend to everyone who is new to flash. It requires only a very simple setup and is well within the capabilities of everyone who has a D-SLR and a hot-shoe mounted speedlight.

It should be noted that none of these images are incorrect, as such. One, or possibly two, of the images will look better to you than the others—and this is individual preference; something you will have to figure out for yourself. Per-

PLATE 5-25. Metering off the white shirt, I place the tone at +1.7 or +2 EV. (SETTINGS: $\frac{1}{160}$ second, f/3.2, 800 ISO; no flash)

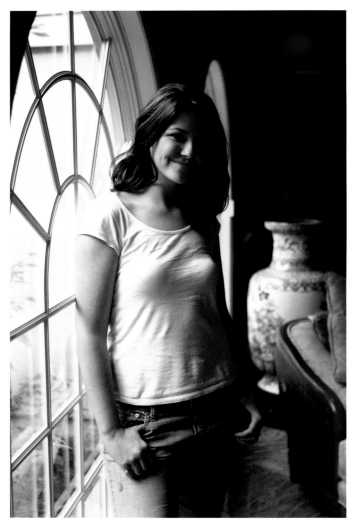

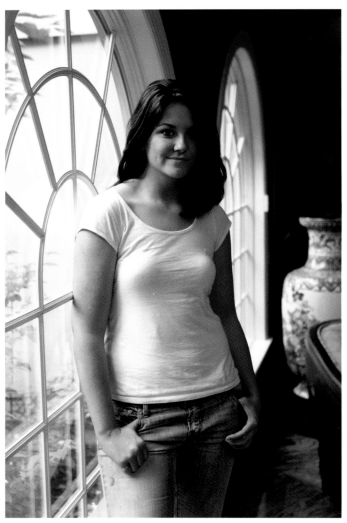

PLATE 5-26. A test shot reveals the image is high in contrast. (SETTINGS: $\frac{1}{160}$ second, f/3.2, 800 ISO; no flash)

PLATE 5-27. Adding fill flash creates a more flattering portrait. (SETTINGS: $\frac{1}{160}$ second, f/3.2, 800 ISO; FEC –1 EV)

sonally, in a scenario like this, I would immediately start at –2 EV (or perhaps –1.7 EV) for my fill-flash setting.

Let's look at a longer view of the same scene. In this next illustrative sequence, the model is turned away from the window. I immediately meter off the white shirt (**5-25**), and place this tone at +1.7 or +2 EV on my camera's built-in meter, making sure I can only see the white shirt—nothing else. Just to double-check my exposure, I take a test shot to look at the histogram, which will then confirm whether or not the basic exposure is correct.

Just as a reference to see the effect that fill flash will have, I make a test exposure (**5-26**). Indeed, the contrast is very high due to the way she is posed against the window.

Adding a touch of fill flash immediately opens up the shadows and makes it a more flattering, casual portrait (**5-27**). I was immediately able to go to a setting of –1 EV flash exposure compensation (FEC) because experience had shown me that this would be a good starting point.

> Indeed, the contrast
> is very high due to
> the way she is posed . . .

Metering Modes

Most modern cameras have three metering modes (or variations of them). These are

> **center-weighted**—The camera's metering is based on an oval-shaped section of what you see in the center of the viewfinder.
>
> **spot-metering**—The camera's metering is based on a very narrow part of the image seen in the viewfinder.
>
> **evaluative/matrix metering**—The area that the camera meters is broken into various sections, which are given different weights. This intelligent metering is a considerable advance over the simpler center-weighted metering.

So which is best? Spot-metering has a specific advantage when you need to meter off a specific tone. However, in the choice between center-weighted and evaluative metering, there isn't much need to anguish over the decision. For anyone who shoots in the manual exposure mode, it doesn't matter all that much which metering mode is used to get to the exact shutter speed/aperture/ISO combination. You'll get the same exposure settings regardless of which metering mode is used.

As mentioned at the start of this section on exposure metering, getting to the correct exposure should be an iterative process employing a variety of techniques—using the camera's built-in light meter, the histogram, blinking highlights, checking the LCD image, and estimating from experience. There are numerous methods you can use to get to correct exposure; which ones to use

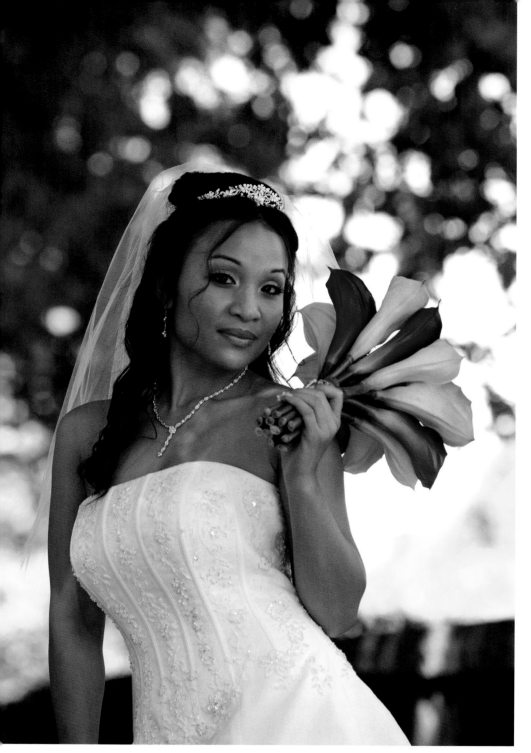

PLATE 5-28. For this image, I started off measuring the bride's dress, placing the metered value at +0.7 EV. Exposure was then quickly confirmed by making a test shot of only the white of the dress and checking the histogram display. Then, flash was added at –2 EV. The exposure was reconfirmed by looking at the LCD. In this way, the exposure was quickly determined—and it can be reconfirmed at any time while shooting. It is important that metering doesn't hamper the flow of photographing your subject; the metering process should be fluidly incorporated in the shoot.

will depend on the specific scenarios we encounter. It's a mix-and-match of different techniques—all used to make sure we get optimum exposure for our images.

As long as you end up at the right combination of aperture, shutter speed, and ISO, it doesn't really matter which metering mode was used. It might, therefore, be simpler to stick to a metering mode of choice and get to know how your camera responds. For tricky metering situations, there is always the considered approach using spot-metering. This allows you to be very specific about the tonality of the area being metered.

Stick to a metering mode of choice and get to know how your camera responds.

6. Flash Modes and Exposure

W hile the previous section took care of exposure metering for ambient light, we have several ways in which we can add different amounts of flash to the mix.

Flash Modes: Manual, Auto, and TTL

When using the manual setting, the flash gives off a specific and set amount of light every time. The output of the flash doesn't vary from photo to photo, unless adjusted specifically on the flashgun (or the power pack, in the case of a studio lighting setup).

With auto flash, the flashgun itself measures the amount of light reflected from the subject and determines the point at which to cut off the light from the flash. A sensor (on the front of the body of most flashguns) measures the light reflected from the area in front of the flash, but does so for a fairly narrow angle, which remains constant. (In other words, the specific lens you have on, or what focal length you have zoomed to, has no effect on the area that the flash measures.)

With TTL flash, the camera's metering system determines correct exposure through the lens (TTL) and then controls the speedlight's output, shutting off the speedlight when enough light has been emitted from it.

Choosing Between the Different Flash Modes

Even though it makes sense to use your camera in the manual exposure mode (for very specific reasons), with flash it is often easier to alternate between TTL flash and manual flash. For example, I find it simpler to shoot in manual exposure mode on the camera but to use TTL flash when my subject isn't a static distance from my flash. On the other hand, when the subject-to-flash distance remains constant, it is nearly always simpler to use manual flash for consistency and control over the light.

For the purposes of this book, my flash is mounted in the camera's hot-shoe the majority of the time, which means that my flash moves in relation to my subject when I move. As a result, most of the examples in this book deal with TTL flash. I would change to manual flash if I had the flash off-camera, or if the subject were static in relation to the flashgun.

We have several ways in which we can add different amounts of flash . . .

You might wonder why I find it simpler to use the manual exposure mode on the camera but still choose to rely on automatic metering technology with the flash.

Basically, when using the camera's manual exposure mode I don't have to second-guess the camera's metering algorithms, which could vary depending on light levels, exposure mode used, lens used, and the evaluative metering system of the camera. When these automated functions are used in conjunction with TTL flash, it becomes fairly difficult to guess how the flash and ambient light are going to work together—and how they are going to be balanced by the camera.

However, when I use the camera's manual exposure mode, many of these variables are now fixed. I control the shutter speed, aperture, and ISO. That only leaves one variable: the flash exposure. That variable is something I can quickly adjust with flash exposure compensation (FEC), which gives me far greater control over my ambient-to-flash balance.

Manual Flash

As mentioned above, there are two distinct ways in which flash exposure is handled. First, flash exposure can be achieved by adding flash as a constant amount of light that is emitted from the flashgun. This is manual flash. The output of flashguns is controlled in fractions of the maximum possible output (*e.g.*, ¼ power or ¹⁄₁₆ power). But a ¼-power setting will result in a different amount of light being output from different models and makes of flashguns.

If you have strobes set up that are in a constant position in relation to your subject, such as with in a studio setup, then the ideal way is to shoot with manual flash. Using a flash meter for this is usually the easiest way to determine exposure. This will fix your exposure to your chosen ISO and aperture.

If you're using on-camera flash and keeping in a static position in relation to your subject, then it also might be easier to use manual flash. This will once again keep your exposures consistent within a series of shots. With digital, you could do a few test shots and chimp (reference the LCD screen) to figure out the correct exposure with your flash in manual. (For a single photograph, it might just be simpler to shoot with TTL flash; see below.)

With manual flash, which is most easily measured with a handheld flash meter, four things control the exposure for our subject:

1. The output level (*i.e.*, the power setting)
2. The distance of the subject from the light source (the flashgun or light modifier)
3. The aperture
4. The ISO setting

This will keep your exposures consistent within a series of shots.

Auto/TTL Flash

The second way to handle flash is as an automatically controlled flash burst. This flash output can either be controlled by the flashgun itself (usually called Auto mode) or by the camera in conjunction with the camera's metering system (otherwise known as TTL flash). With modern D-SLRs, the Auto mode functions in a manner that is fairly similar to TTL flash. Hence, for simplicity of explanation, we will only consider manual flash and TTL flash from here on.

Since manual flash is set to a specific level of output, neither our subject's reflectivity nor our choice of composition (*i.e.*, how we decide to frame our subject) has any impact on our exposure metering. With Auto/TTL flash, on the other hand, the flash output is varied and controlled by the flashgun or by the camera's metering system. This means that, within a certain usable range, neither our chosen aperture/ISO nor the distance to our subject, influences our exposure.

The factors that *do* affect our exposure are the reflectivity and tonal values of the subject and the scene. Your camera's meter will try to expose any scene in the frame as an average tone, neither bright, nor dark. This is true for automatic flash, as well. As a result, you will have to use flash exposure compensation (FEC) to get optimal results if your flash is the dominant source of light. If you are using flash as fill for daylight images, the best results are usually achieved with the FEC dialed down. Hence, the reflectivity of the subject will seem to have less impact on the exposure, since our exposure will be primarily for the ambient light.

When I shoot this way outdoors, I usually dial my speedlights down to around –2 to –3 stops. (I use the Nikon speedlights in TTL BL mode, which balances the flash automatically with the ambient light [see TTL Modes, below]). The setting I choose also depends on how much flash is needed. If we're photographing someone in the shade and need to bump the exposure up to match a sunlit background, then we're going to need a lot more flash. Therefore the flash exposure compensation will most likely be around zero.

It is impossible to give specific settings, since the lighting and shooting conditions can vary so much. There simply aren't do-it-all camera settings that will cover every possibility. It is more important to understand the concepts and the reasoning needed to determine the right settings. By combining this with an understanding of how to best use our flashguns, we'll be able to adapt to various situations and still produce great results.

TTL Modes. With Nikon's flash system, you have the choice between TTL (standard TTL) and TTL BL (balanced fill-flash TTL). You can change between these modes on the speedlight itself. With TTL BL, the camera's metering system takes into account the available light and will reduce the flash output accordingly. This is, therefore, the TTL mode to use for more pleasing fill-flash results. In my experience, when flash is the dominant source of light, however,

> The second way to handle flash is as an automatically controlled flash burst.

more consistent results can be achieved by switching to standard TTL. (*Note:* There are numerous phrases used to describe each variant of TTL flash, but essentially they can be broken down into those two subsets.)

Canon has a similar way of dealing with their version of TTL flash, but they call these options evaluative flash metering and average flash metering. These settings are chosen in the camera's menu. If you want a more subtle fill flash, it makes sense to stick to evaluative flash metering. However, if you use flash consistently as the dominant source of light, then average flash metering may well give you more consistent results.

Flash Exposure Compensation

There are two different kinds of exposure compensation. Overall exposure compensation is set on the camera body and affects both the ambient and the flash exposure for Nikon, but only the ambient exposure for Canon. Flash exposure compensation affects the flash output only; the ambient exposure is unaffected. This can always be set on the flashgun itself, but some cameras also have a button on the camera body where the flash compensation can conveniently be set without taking your eye from the viewfinder.

Overall exposure compensation is used with the automatic metering modes. However, with most Nikon cameras, dialing exposure compensation in the manual exposure mode will bias the camera's built-in light meter even for manual exposure. With Canon, you can't dial exposure compensation in the manual exposure mode (see sidebar above).

Flash exposure compensation is used to compensate for the flash output when the flash is used in Auto or TTL mode. Obviously, it can't be set when the strobe is used in the manual output mode.

First, let's review exposure compensation in general. There are two concepts to keep in mind:

1. When the scene/subject is light in tone, you'll increase exposure.
2. When the scene/subject is dark in tone, you'll decrease exposure.

As discussed in chapter 5, this is due to the fact that your camera's meter will suggest an exposure setting designed to render everything as a middle gray tone. Hence, if you are using one of the auto modes (or Auto/TTL flash) with no exposure compensation, someone in a white dress against a white wall will be underexposed; you need to bump up the exposure compensation for lighter-toned scenes. The same reasoning goes for darker-toned scenes. A man in a

Cumulative Exposure Compensation with Nikon Cameras

The Nikon bodies I have worked with allow you to set overall exposure compensation even when you have your camera set to the manual exposure mode. This allows you to bias the metering.

With Nikon, the overall exposure compensation and flash exposure compensation is cumulative—at least to an extent. For example, if you were to dial in +1.0 EV overall exposure compensation setting on the camera and –1.0 EV flash compensation setting, they would cancel each other—but only for a scenario where the ambient light is low and the flash was your main source of light. Where the ambient light levels dominate, and flash is used as fill only, different algorithms come into play. Factors such as the flash-sync speed and available apertures affect the scenario as well. Hence, the flash and exposure compensation might affect the ambient light exposure differently.

With Canon, flash exposure compensation and overall exposure compensation aren't linked in this way. With a Canon D-SLR in the manual exposure mode, you can only set the flash exposure compensation, not the overall exposure compensation.

> With Canon, you can't dial exposure compensation in the manual exposure mode . . .

dark suit against a dark brick wall will be overexposed if the camera is allowed to make its own decision; you need to reduce the exposure compensation setting for darker-toned scenes.

To make it even more clear, let's think about this scenario. We have a setting where the light is consistent and even—so there will be an exact combination of aperture/shutter speed/ISO settings that will provide the correct exposure for the skin tones. Yet, if our subject dresses in all black or all white clothing, our automatic meter reading will change—even though the light hasn't changed. We would still need the same exposure, regardless of the variation in our camera's light meter reading. If you insisted on using automatic exposure, you would have to use exposure compensation to compensate. Further, you would have to vary your exposure compensation depending on your composition; the size of the light/dark patches of clothing and background areas would also affect your meter reading.

The same reasoning goes with using Auto/TTL flash: you have to adjust your flash exposure compensation (FEC) in response to the tonality of the scene in front of your lens.

With TTL/Auto fill flash, you will most often dial down your flash exposure compensation to give only a tiny bit of fill light. Your flash exposure compensation will be around –1 to –3 EV. (Again, this depends on the tonality of your subject.) When your flash is your main source of light, you will usually hover your flash exposure compensation around 0 EV to +0.7 EV, depending on the camera, the camera system, and—of course—the tonality of your subject and scene. So your flash exposure compensation could still range anywhere from around –2 EV to +3EV.

Once again I want to stress a particular point: there are no specific or fixed settings. There are just too many variables for anyone to give specific do-it-all settings. The factors that would affect how much flash exposure compensation needs to be dialed in include:

1. The reflectivity of your subject
2. How much of your frame is filled by the subject
3. How far the subject is from the background
4. Whether the subject is off-center or centered in the frame
5. The individual camera's exposure algorithms
6. The available light (this ties in with how the camera's metering algorithms work)
7. Any backlighting (strong backlighting always requires a lot more flash exposure compensation)

Therefore you have to juggle all this when figuring out how much flash exposure compensation to dial in. This is a seemingly tough task that gets easier with

> You have to adjust your flash exposure compensation in response to the tonality of the scene . . .

experience. Here's a hint, though: when your flash acts only as a fill light, the flash exposure compensation can vary a lot without affecting the quality of the final image much. Fill flash exposure compensation of –2 EV will look slightly different than –3 EV, but the actual photo won't be incorrectly exposed with either setting. If your flash is the main source of light, on the other hand, a full stop incorrect exposure would be a lot—and it might very well mean the image is a flop in terms of exposure. Careful and subtle use of flash should always be the aim, of course.

The actual amount of flash exposure compensation can be fine-tuned by looking at the camera's LCD. Adjust it to taste; don't get stuck on the specifics. Here's a rough guide to get you started with making flash-exposure compensation settings for fill flash:

> fill flash in the same direction as the sun (or available
> light): –3 to –1 EV
> fill flash 90 degrees to the sun (or direction of available
> light): –2 to 0 EV
> fill flash against the sun (or direction of available light): –1
> to +1 EV

The exact ambient exposure here will depend on what the background looks like and how it is lit. For example, you could allow the background to blow out a bit (overexpose it) and then use just a touch of fill flash on the subject, who is shaded against the ambient light. In this case, a setting of –3 EV would work even when shooting against the direction of the sun (or direction of the main source of available light). As I said, don't get locked into specific recipes. Adjust your settings to taste by thinking about what you're trying to achieve.

The conclusion here is that, ultimately, it is best to know how your specific camera and flash reacts in various scenarios and various lighting conditions. There is only so much that can be learned outside of actual experience and continual practice. You have to know your equipment.

The exact ambient exposure here will depend on what the background looks like . . .

7. Flash-Sync Speed

At the start of the book I promised that there would be only one technical diagram—and here it is (or the first part of it, at least). To understand certain effects and limitations with flash photography, whether manual flash or TTL flash, we need to understand how the shutter mechanisms in our cameras work. The explanation here doesn't try to cover all the possibilities, such as electronic shutters, but it has been simplified for a clear initial understanding of the mechanism by which a camera's shutter functions.

The Pre-Flash Sequence

In plate 7-1, you'll note that there is a pre-flash sequence before the shutter even opens. This is what the TTL flash exposure system uses to calculate the amount of flash it needs to emit during the actual exposure interval to give correct exposure. Normally this pre-flash sequence is so fast, and so close to the main burst of flash, that it is not discernable to the eye. (We'll come back to this point again when we discuss first-curtain and second-curtain flash-sync [see pages 47–48].)

Maximum Flash-Sync Speed

The shutters in modern D-SLRs consist of two curtains that run vertically. In the first part of this diagram (plates **7-1**), you can see the first curtain in place; it is closed and keeping light from the sensor. The moment that you trip the shutter, the first of the two curtains starts moving across the sensor gate, allowing light to hit the sensor. At a specific time interval later, the second curtain moves across the sensor, closing it so that no more light can fall on the sensor. The time interval between when the first curtain opens and the second curtain closes determines your shutter speed.

PLATE 7-1. Flash must be synchronized with the movement of the shutter curtains to create a proper exposure.

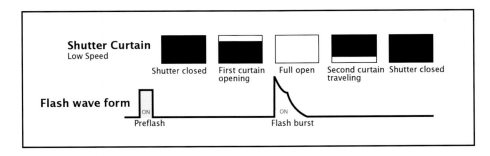

There will be shutter speeds long enough that the entire sensor is revealed (no part of it obscured by either of the curtains). Similarly there will be shutter speeds high enough that, during the exposure, at least one of the two curtains will always be partially obscuring the sensor. On every camera, there is a specific shutter speed at which the first curtain has just cleared and the second curtain is about to move across. This is the fastest shutter speed at which the sensor is

completely revealed. It is, accordingly, the fastest shutter speed at which you can use your flash on most cameras. For this reason, it is known as the maximum flash-sync speed.

Since the flash is a near-instantaneous burst of light, we need the camera's shutter to be completely open (and the sensor completely revealed) for the flash to expose the entire frame. The maximum flash-sync speed varies for the different camera models, but $\frac{1}{250}$ second is a very common value for this.

Taking an image at a shutter speed that is *slower* than the maximum flash-sync speed will not present a problem; the entire frame will be exposed to the flash. However, because the shutter curtains are remaining open for a longer duration,

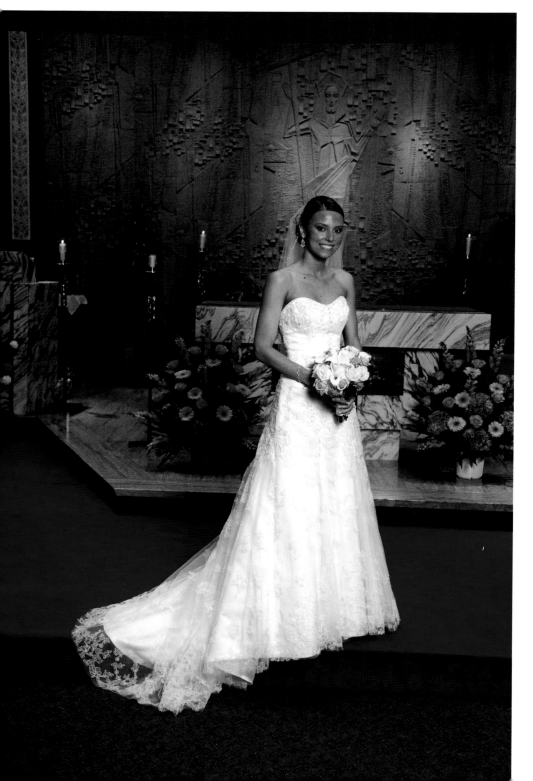

PLATE 7-2 (LEFT). With the shutter speed set at or below the maximum flash-sync speed, the image is properly exposed by the light from the flash. (SETTINGS: $\frac{1}{80}$ second, f/5, 500 ISO)

PLATE 7-3 (ABOVE). When the shutter speed exceeds the maximum flash-sync speed, the second shutter curtain blocks the light of the flash from hitting some of the film or image sensor. This yields a dark band. (SETTINGS: $\frac{1}{320}$ second, f/5, 500 ISO)

the image sensor will also be exposed to any ambient light in the scene. If the ambient light levels are well below that of the flash exposure (at least 2 or 3 stops less), the ambient light won't have an appreciable impact on the image, even with longer shutter speeds.

When images are taken at any shutter speed *faster* than the flash-sync speed, on the other hand, problems can occur. This is because the second curtain will start to move across the sensor and obscure part of the flash exposure. (*Note:* This is actually "old school" technology—before high-speed flash-sync, which we'll get to shortly.) Anyone who has worked with studio lighting, will have made the mistake, at some point, of setting their camera to a shutter speed faster than the flash-sync speed. The result is a black band obscuring part of the image. Because the shutter speed was too high, one of the shutter curtains blocked the near-instantaneous light of the flash from reaching the film or image sensor.

High-Speed Flash-Sync

Fortunately, this flash-sync problem is nearly impossible to get with a modern dedicated speedlight. The intelligence built into the camera and flashgun system doesn't allow this to happen. When the camera detects the dedicated speedlight, the camera will either stop the shutter speed from going higher than maximum flash-sync speed, or will switch to high-speed flash-sync. In this mode, instead of a near-instantaneous burst of light, the flashgun emits a slower, pulsed light. The light from the flash is now, effectively, continuous light.

The result is a black band obscuring part of the image.

PLATE 7-4. Flash must be synchronized with the movement of the shutter curtains to create a proper exposure.

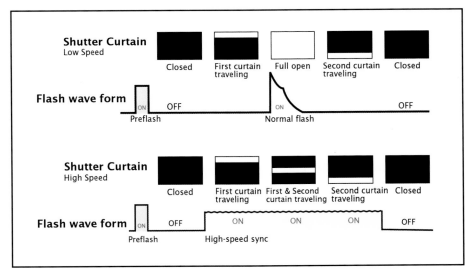

When shooting at a shutter speed higher than the maximum flash-sync speed, where the shutter speed is too fast for an instantaneous burst of light to record across the entire sensor area, the opening between the shutter curtains will essentially be a slit moving over the sensor. With high-speed flash-sync, the flash is now continuous light and will be recorded across the entire sensor as the shutter curtains travel down. As a result, we can now sync our flashguns up to ridiculous speeds, like $\frac{1}{4000}$ or even $\frac{1}{8000}$ second. This allows us to use flash in

bright conditions at very high shutter speeds—or to use wide-open apertures for better control over our depth-of-field.

There is a downside, though. Changing the flashgun's mode also dissipates the light, transforming it from a fast, high-energy pulse to a lower-energy continuous one. This means we lose range with our speedlights. Since our flash is putting out less power, we need to be closer to our subjects.

Flash Efficiency and Range

So, even though most modern D-SLRs feature high-speed flash-sync—and it would *seem* like we're not bound by the limitations of older-generation cameras—we still need to be aware of our camera's maximum flash-sync speed and the implications of it. In short, the maximum flash-sync speed provides the most efficiency from our flash.

The concept is, once again, best illustrated by checking your own camera and flash. Start by setting your flashgun to point directly forward (*i.e.*, not in any kind of bounce position). Also, make sure your flash exposure compensation is set to zero. Then (using the values in plate **7-7**, equivalent values for a typical sunlit scene), set your camera to ⅟₆₀ second at f/22 and 100 ISO. Note the range on your flashgun display. It should be in the order of 2 meters (7 feet). Not all speedlights have displays that show the range for which the flashgun can give correct exposure, but the better models do. The displays shown in plates **7-5** and **7-6** are typical.

As you change either your aperture or ISO setting, you will see the range change—this is the distance range for which the flashgun can give you correct exposure. These are the real-world limitations of just how much light your flashgun can deliver.

Now, progressively change both the aperture and shutter speed on your camera (again, use plate **7-7** as a reference) and note the change in range on the flashgun's display. (Even though shutter speed doesn't affect flash exposure, it is necessary for illustration here to change the shutter speed, too.)

> In short, the maximum flash-sync speed provides maximum flash efficiency.

PLATES 7-5 AND 7-6. The flash range displays on a Canon 580EX II (left) and Nikon SB-800 (right).

What should be apparent now is that as the aperture is opened up, the flash-gun's range increases. With a bit of thought, this should be self-apparent: a wider aperture will allow more light, and hence will allow greater reach for light from our flashgun.

PLATE 7-7. As you progressively change both the aperture and shutter speed on your camera (use the chart as a reference), note the change in range on the flash-gun's display.

SHUTTER SPEED	APERTURE	ISO SETTING
$\frac{1}{2000}$ second	f/4	100 ISO
$\frac{1}{1000}$ second	f/5.6	100 ISO
$\frac{1}{500}$ second	f/8	100 ISO
$\frac{1}{250}$ second	f/11	100 ISO
$\frac{1}{125}$ second	f/16	100 ISO
$\frac{1}{60}$ second	f/22	100 ISO

If you haven't enabled high-speed flash-sync, your camera should max out between $\frac{1}{125}$ second and $\frac{1}{250}$ second. (*Note:* Cameras like the Nikon D70 and D40 have a maximum flash-sync speed of $\frac{1}{500}$ second and will max out there.)

If your camera has high-speed flash-sync capability, enable high-speed flash-sync now. (*Note:* This is set on the Canon speedlight itself, or in the menu of your Nikon D-SLR; Nikon calls it Auto FP mode.) You should now be able to set a shutter speed higher than your maximum flash-sync speed—but you will immediately notice that if you go even $\frac{1}{3}$ stop over maximum flash-sync speed, your flashgun's range drops by at least *half*. You can now set your camera to $\frac{1}{2000}$ second at f/4. However, where we noticed previously that as we opened up our aperture we gained more range on our speedlight, we now have hit some kind of ceiling around our maximum flash-sync speed.

This little demonstration shows us that we have the most range from our flashgun at the maximum flash-sync speed. This is a very important fact to grasp when we need to balance a subject in shade against a bright background. We have a greater chance of matching a subject in shade against a bright background with our flashgun when we use it at the maximum flash-sync speed. At this shutter speed, we get the widest possible aperture *and* the most output from our flashgun since we remain in the high-energy mode of flash dissipation (not high-speed sync). We'll return to this topic again in chapter 14.

Is a Higher Maximum Flash-Sync Speed Better?

A question I often see asked on Internet photography forums, is whether having $\frac{1}{250}$ second flash-sync at 100 ISO (on a camera like the Canon 10D) is the same as having $\frac{1}{500}$ second flash-sync but being limited to 200 ISO (such as with the Nikon D70). In short, the answer is no, it's not the same. The camera with the higher flash-sync speed has a distinct advantage. Not only is it able to stop motion better and give you better control over depth of field, but, more importantly, the higher flash-sync speed gives your flashgun greater range.

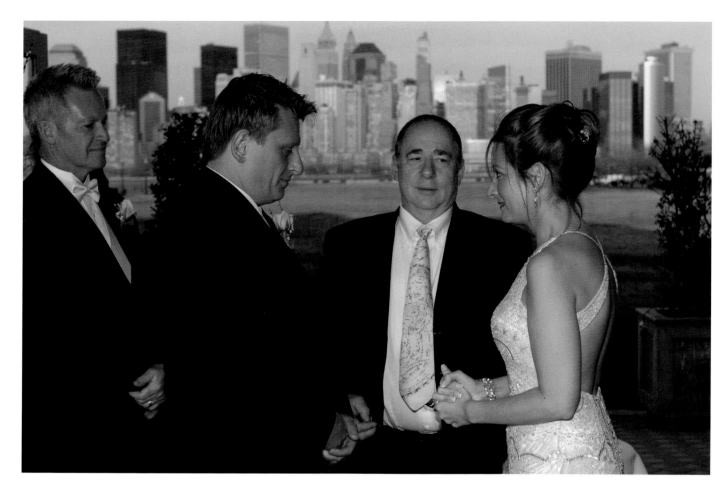

PLATE 7-8. Here's a common scenario where flash and ambient lighting need to be combined.

The reason for this is that a change in ISO will affect both ambient light exposure *and* the flash exposure, as does your choice of f-stop. However, flash exposure is not affected by the choice of shutter speed (as long as you remain within flash-sync range). This higher shutter speed, then, will allow you to use a wider aperture—and this gives you a greater flash range.

At first glance, it seems logical that $\frac{1}{250}$ second at 100 ISO might effectively be the same as $\frac{1}{500}$ second at 200 ISO, but it isn't that simple where flash is concerned. Let's look at an example to help us step through this—and let's base it on an actual scenario.

In the example image (plate **7-8**), the couple is getting married inside a venue. The sliding doors are open and you can see New York's skyline in the background. Our goal is to balance the couple perfectly with the background skyline. If we exposed for the ambient light on the couple, the background would wash out completely. Alternately, if we exposed for the skyline, the couple would appear silhouetted. This might be a cool idea for a photo or two, but it won't be acceptable for an entire wedding sequence. We'll need to use flash.

The actual EXIF data for plate **7-8** says $\frac{1}{250}$ second at f/6.3 and 200 ISO—but let's keep it to round figures for simplicity of explanation here. Let's say we have light outside that gives us $\frac{1}{250}$ second at f/5.6 and 100 ISO for the background (equivalent to $\frac{1}{250}$ second at f/8 and 200 ISO). And, let's say our flash's

If we exposed for the ambient light on the couple, the background would wash out completely.

guide number is such that, at the distance we are standing away from them, the most we can squeeze out of it is f/4 at 100 ISO.

This means that the photographer with a maximum flash-sync speed of $\frac{1}{250}$ second, in this example, will always be one stop under for his flash exposure (f/4) compared to the ambient light (f/5.6). His background here will be one stop overexposed compared to his flash exposures. (It's also very important to note that changing the ISO does nothing in terms of balancing flash with ambient light. The ISO affects ambient exposure and flash exposure equally.)

On the other hand, the photographer with a maximum flash-sync speed of $\frac{1}{500}$ second can just bump his shutter speed to $\frac{1}{500}$ second. Doing this, his ambient light exposure becomes $\frac{1}{500}$ second at f/4 and 100 ISO. It would seem that the coordinating limit of only having 200 ISO as a minimum is a limitation, but this really isn't an issue in terms of being able to balance flash with available light. In this case, it gives him an ambient exposure of $\frac{1}{500}$ second at f/5.6 (200 ISO)—perfectly in balance with the flash exposure he is able to get here.

As you can see, someone who has only $\frac{1}{125}$ second maximum flash-sync speed (such as on the Fuji S2) has a two-stop disadvantage compared to someone with a $\frac{1}{500}$ second flash-sync speed (such as on the Nikon D70). By the way, in plate **7-8** I had to trigger other strobes for additional light and to give some degree of modeling that straight-on flash wouldn't have.

First-Curtain *vs.* Second-Curtain Sync

The timing of when the flash is triggered can be changed in relation to which curtain (first or second) is about to move. We can either trigger our flash at the start of the exposure interval, when the first curtain has just cleared the sensor, or near the end of the exposure interval when the second curtain is just about to start to move.

When we use slow shutter speeds, the decision as to when the flash should be triggered can have a pronounced effect on how the flash appears in our image. This is especially true if our subject moves laterally across the frame. If

> When the flash should be triggered can have a pronounced effect on how the flash appears . . .

PLATE 7-9 (LEFT). This is what you would see with first-curtain sync at a low shutter speed.

PLATE 7-10 (RIGHT). This is what you would see with second-curtain sync at a low shutter speed.

we trigger the burst of flash just as the first curtain has cleared the sensor, we then have the ambient exposure during the rest of the exposure interval until the second curtain closes. The effect is similar to that seen in plate **7-9**. The ambient exposure creates a ghosting effect moving "out" of the subject that is frozen by the burst of flash.

When we trigger the burst of flash just at the end of the exposure interval, just as the second curtain is about to move, then we have the ambient exposure first. This is then punctuated by the subject that is frozen by the burst of flash. (*Note:* If you pan with the subject, however, the subject is effectively static within the frame and second-curtain sync creates very little difference in comparison to using first-curtain flash sync.)

If we have our subject moving across the frame and use second-curtain sync like this, the image seems to make more sense visually. Therefore, it would seem like a good idea to keep the flash set to second-curtain sync as a default. Because of the pre-flash sequence, however, it isn't that simple.

The Pre-Flash Sequence

As seen in plate **7-1** (on page 41), the pre-flash sequence is a short burst of light emitted before the shutter opens—before the main burst of flash. The camera uses this to calculate TTL flash exposure. Normally, the pre-flash sequence is so fast and so close to the main burst of flash that it is not discernable to the eye. However, we *can* set our cameras so that we can actually see the pre-flash sequence separately from our main burst of flash.

As an example to see this, set your camera's shutter speed to 1 second exposure. The aperture and ISO don't matter, but let's just set them to f/5.6 and 200 ISO for purposes of the explanation. Next, switch your speedlight on and set it to a TTL mode. Keeping your flashgun in the default mode of first-curtain sync, trip your shutter and observe the flash output. It should appear as a single burst of flash, even though it included the pre-flash sequence.

Then, set your flash to second-curtain sync (also called rear-curtain sync). This is done on the speedlight itself if you use Canon, or on the camera's body when you use Nikon. (Refer to your owner's manual to see which buttons they are.) Continuing to work at a shutter speed of 1 second, trip your speedlight. You should now see two distinct bursts of flash. The first burst is the pre-flash. The second burst of flash is the actual exposure and now takes place just before the second curtain closes.

This pre-flash sequence, which is now distinctly noticeable at slower shutter speeds, can often cause people to blink (or start blinking). When you take their photo, this blink is then what you capture during the actual exposure interval. In my experience, it best to keep the flash set to first-curtain flash-sync unless a very specific artistic effect is needed. This way you can minimize, if not eliminate, photos that are ruined because of blinks and closed eyes.

> We can set our cameras so that we can actually see the pre-flash sequence . . .

8. Adding Flash to Ambient Light

Combinations of Shutter Speed, Aperture, and ISO

In the illustrative sequence that follows, we can clearly see how our available light changes in brightness as we change our settings. This can be seen in the background through the window. Equally important to note is that the TTL flash exposure on our model remains quite consistent from image to image. (There is some minor variation between some of the images, as would happen with any kind of automatic metering.)

If our flash exposure is our dominant light source and the ambient light levels are low in comparison, we can (within a reasonable range) choose any settings and expect our TTL flash metering to give us a correct exposure. Our aperture, shutter speed, and ISO choices will affect how our available light appears in our final image. Obviously, our depth of field and noise characteristics will also change. Still, our TTL flash exposure will remain the same.

This is such an important part of TTL flash metering that I would like to repeat it for emphasis: when the ambient light levels are low in comparison to our chosen camera settings, we can (within a fairly wide range) choose any combination of settings and have our TTL flash exposure remain the same. For an example, see plates **8-1** through **8-9** (next page).

Dragging the Shutter

> You can, therefore, vary the shutter speed to change the ambient light exposure.

"Dragging the shutter" is a term used to describe the technique of using a slow shutter speed—slower than the flash-sync speed—in order to allow a measure of ambient light to register when using flash. As explained in the previous section, shutter speed (as long as it remains below the maximum flash-sync speed) has no direct effect on *flash* exposure. You can, therefore, vary the shutter speed to change the *ambient light* exposure. Bringing the shutter speed down low enough that available light registers on the image lets you retain the mood of a setting by not overpowering it with flash.

The phrase "dragging the shutter" originates from an era when photographers would determine correct flash exposure for on-location photography by setting the ISO speed according to the film used, setting the aperture according to subject distance (based on the flashgun's guide number), then using the shutter speed as the only way of independently allowing more ambient light

 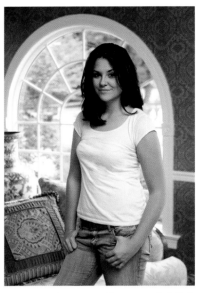

PLATE 8-1. (SETTINGS: ¹⁄₁₂₅ second, f/5.6, 800 ISO; FEC: +0.7 EV)

PLATE 8-2. (SETTINGS: ¹⁄₁₂₅ second, f/4.0, 800 ISO; FEC: +0.7 EV)

PLATE 8-3. (SETTINGS: ¹⁄₁₂₅ second, f/2.8, 800 ISO; FEC: +0.7 EV)

PLATE 8-4. (SETTINGS: ¹⁄₂₅₀ second, f/5.6, 400 ISO; FEC: +0.7 EV)

PLATE 8-5. (SETTINGS: ¹⁄₂₅₀ second, f/4.0, 400 ISO; FEC: +0.7 EV)

PLATE 8-6. (SETTINGS: ¹⁄₂₅₀ second, f/2.8, 400 ISO; FEC: +0.7 EV)

PLATE 8-7. (SETTINGS: ¹⁄₂₅₀ second, f/5.6, 800 ISO; FEC: +0.7 EV)

PLATE 8-8. (SETTINGS: ¹⁄₂₅₀ second, f/4.0, 800 ISO; FEC: +0.7 EV)

PLATE 8-9. (SETTINGS: ¹⁄₂₅₀ second, f/2.8, 800 ISO; FEC: +0.7 EV)

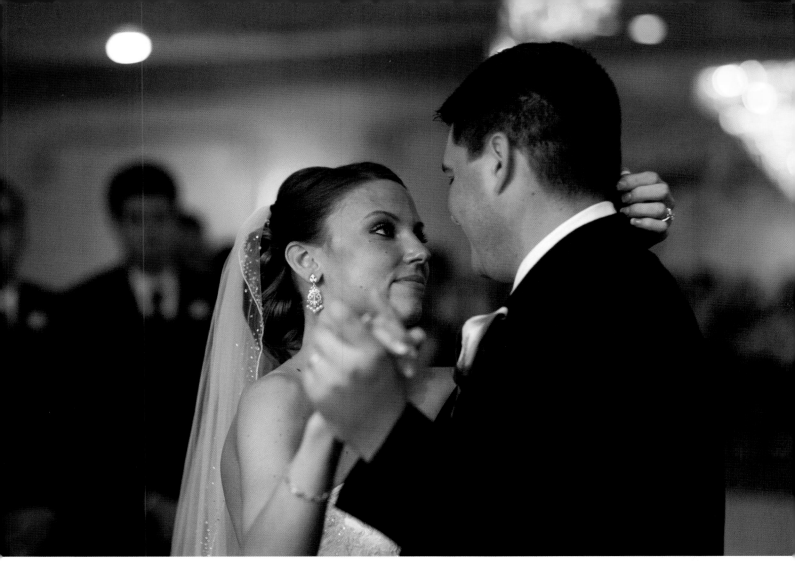

PLATE 8-10. (SETTINGS: $\frac{1}{160}$ second, f/1.8, 1600 ISO; flash gelled with $\frac{1}{2}$ CTS filter)

in—slowing the shutter speed far lower than the maximum flash-sync speed when shooting in low light. (*Note:* This worked fairly well for color negative film, because the labs took up the slack in exposure miscalculation when printing the images.)

With TTL flash on a D-SLR, you have more flexibility than this. Therefore, I'm of the opinion that the phrase "dragging the shutter" is archaic in the era of TTL flash photography. As explained on the previous pages, TTL flash exposure will follow your chosen aperture and ISO. This means that your choice of aperture and ISO effectively become "transparent" to your flash exposure. Hence you can equally well use your aperture, your ISO, and your shutter speed to allow more or less ambient light in—all independent of your TTL flash exposure. (Obviously we have to work within reasonable ranges.)

So, don't get locked into the idea of "dragging the *shutter*" to control your available light. Let's look at all of this in relation to some images. Looking at the settings for plates **8-10** and **8-11**, you can see that the shutter speeds weren't all that slow, yet the available light most definitely did register, giving context to the images. This was because of my choice of aperture and ISO. Adding TTL flash to the available light and exposing correctly for the subjects opened up

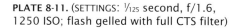

PLATE 8-11. (SETTINGS: $^1\!/_{125}$ second, f/1.6, 1250 ISO; flash gelled with full CTS filter)

This technique has become

a lot more interesting

and versatile.

the shadows, controlled the contrast, and cleaned up the skin tones. I didn't specifically need to "drag the shutter" to get to this point.

What is at the very heart of this is the idea that you get better results with on-location flash photography when you make sure your ambient light registers to some extent—whether you use your aperture, ISO or shutter speed. With modern (*i.e.,* TTL) flash photography, this technique has become a lot more interesting and versatile.

9. Using Simple Flash Modifiers

All flash modifiers do essentially the same two things. First, they spread most of the light all around/upward. Second, they throw a small measure of light forward to help avoid shadows under the subject's eyes. These devices can be helpful—but whether to use a light modifier, what kind to use, and the angle at which you have your speedlight tilted and rotated all need to be active decisions based on the specific scenario you're shooting under. Avoid the mindless default of popping a diffuser cup on and tilting your flash head to 45-degree angle. In fact, in the previous chapter I illustrated circumstances in which any of the popular flash modifiers would *not* have helped (or would have given less satisfactory results).

PLATE 9-1. Here is a small selection of the wide array of flash modifiers that are available on the market.

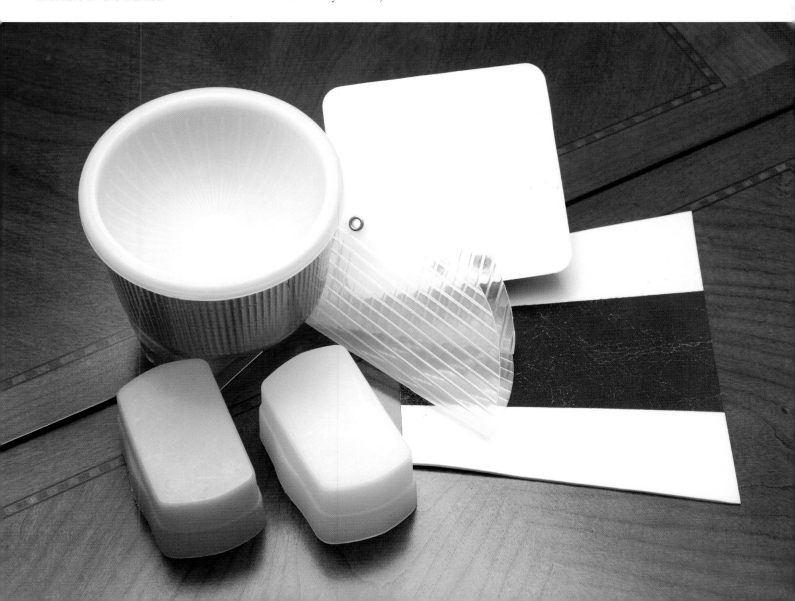

The important thing to remember about flash modifiers is that there simply is not *one* light modifier that will give you the best results in *all* situations. If you do find one that works well in a certain situation, it should remain exactly that: a technique you use in specific situations where it gives you the best results.

For example, plate **9-2** would have looked very different if I had used a generic light modifier. Notice that the bride's arm and side of her face (and veil) closest to the camera are the *darker* parts of the image. Her reflection in the mirror is brighter than the foreground. I was able to do this because I used a kind of half-snoot (described in detail in the next few pages) to very specifically direct my light away from her. I pointed my flashgun toward a specific part of the ceiling and room. I knew that, from that direction, the light would reflect at an angle that would illuminate the front of her face more than her back.

This would not have been possible at all with a generic light modifier that throws light forward from the camera's point of view and disperses light all around the room. A generic light modifier would have flattened the light completely and made her arm and her veil much brighter than her face's reflection in the mirror.

_Our next set of images shows a typical example using a standard Stofen Omnibounce light modifier on the flashgun. As you can see in the first frame (plates **9-3** and **9-4**), using the Stofen helps to disperse some light and is a huge step up from direct flash. However, the light from top to bottom is uneven. The

Her reflection in the mirror is brighter than the foreground.

PLATE **9-2.** With a generic light modifier that throws light forward, this image would not have been possible. (SETTINGS: 1/80 second, f/5, 1600 ISO; FEC +1.7 EV)

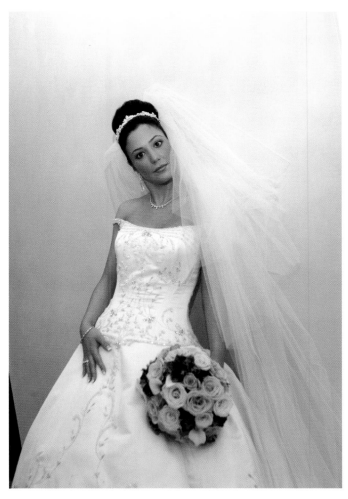

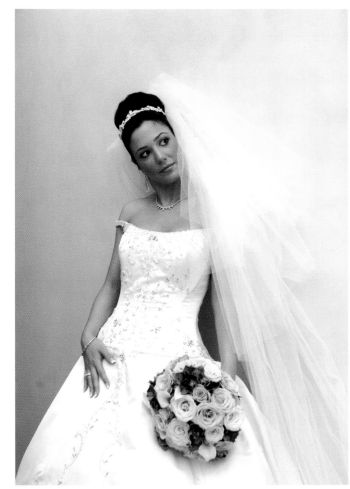

PLATES 9-3 (ABOVE) AND 9-4 (LEFT). Using the Stofen Omnibounce provides a much better result than direct flash—but there is still room for improvement.

PLATES 9-5 (ABOVE) AND 9-6 (LEFT). Bounce flash off a nearby wall creates a softer, more appealing look that totally changes the image.

detail image reveals that there is also a hard shadow on the bride's face and some specular reflection on her skin from the flash directly from the Stofen. In some way, anytime there is flash directly from the flash modifier on your subject, you get this kind of light. It is inevitable.

To create a better look (plates **9-5** and **9-6**), I simply took the Stofen off and pointed the flash over my shoulder into the rest of the hallway. As you can see, having only *indirect* light from the flashgun completely changes the look of the image. This can clearly be seen in the detail image.

The key idea here is that bouncing your flash does not mean simply putting a flash modifier on your flashgun and pointing it at the ceiling. There are times when I *do* want to throw light forward from my flashgun, but this is a specific choice—whether it's a shortcut, an intentional creative technique, or just a way of dealing with the limitations of the scenario I'm working in.

My Choice of Flash Modifiers

When using devices to modify the output from my on-camera flash, I try to keep close to that fundamental principle in lighting: the larger your light source, the softer your light.

Using any of the myriad flash modifiers on the market today will help in achieving that softer light. These modifiers spread the light from the on-camera speedlight much wider than it would otherwise be, making it much softer light than direct flash would be. However—and this is a big *however*—these flash modifiers also throw light forward. This creates lighting that is not only soft, it's flat. I much prefer soft, *directional* lighting.

The way I achieve soft, directional light from my flash is by bouncing the light from the flash off different surfaces—and by not getting much spill light on my subject. This is accomplished by flagging my on-camera flash. Flagging is the term used to describe directing or blocking light. For plate **9-7**, I did this

PLATE **9-7.** In this photo of a little ring-bearer wanting to smell the bride's flowers, I bounced flash off to my left and upward toward the ceiling away from me. The direction from which the light is falling can easily be seen from the modeling of light on the boy's face. An additional advantage in bouncing the flash like this is that the light comes in at a low angle, so there will be a catchlight in the eyes to give them that bit of sparkle. (SETTINGS: $\frac{1}{50}$ second, f/3.2, 2000 ISO; FEC +0.3 EV)

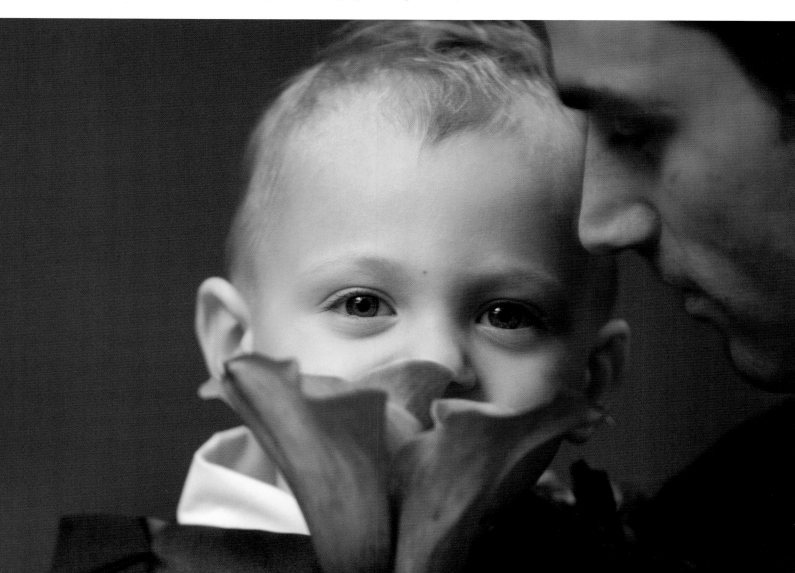

PLATE 9-8. By gelling my flash for tungsten, I change the grungy orange backgrounds to a more pleasing warm tone. The gel used in the image of the ring-bearer (plate 9-7), was full CTO. I keep my camera's white balance to tungsten when shooting this way. Then, in post-production, I fine-tune the white balance (because I bounced my flash, the light picked up an additional color from the walls and ceiling). The gel shown in the illustration here is ½ CTS. When shooting with this, I keep my white balance at 3800K, still much closer to tungsten than the 5400K of the flash.

PLATES 9-9 AND 9-10. This simple black-foam modifier allows me to keep direct flash from spilling onto the subject.

by adding what is, in effect, a half-snoot to my on-camera flash (see below) for an image of this). This half-snoot partially blocks the light, but it also directs it.

For the photo of the ring-bearer, I also gelled the flash to bring the color balance from the flash close to that of the available (tungsten) light. This helped bring the cold light of the flash closer to the warm tones of the tungsten light. I simply stuck a piece of gel over the head of my Speedlight with some gaffer's tape. It is low-tech, but it works.

The black half-snoot that I add to my speedlight is just as simple. It's a piece of thin black foam bought from an arts store, then cut to size. I keep the piece of black foam fastened to my speedlight with a hair band that I stole from my daughter. Yes, it's low-tech—but it's simple and it works!

PLATE 9-11. The additional advantage with this light modifier is that you retain the cool, all-black, stealthy ninja-photographer look.

This piece of black foam around my speedlight has two advantages. First, it lets me create directional light, putting the light precisely where I want it. Second, it is less annoying to others. When turning my flash to the side or to point behind me, I risk blasting other people directly in the face with flash. This piece of black foam keeps that from happening. I now direct my flash over people's heads, so no flash hits bystanders directly in the eyes. That is the flash modifier I most often use. Its total cost is less than two dollars.

The only other light modifier that I use is a Stofen Omnibounce, which I use when I am in a situation where I do need light thrown directly forward. I also use it in rooms where the ceiling would not allow me to successfully shoot bounce flash with the black half-snoot. This can be the case when the ceiling is too high, when it's painted a dark color, or when you encounter a wooden ceiling. I also specifically use a diffusion cup indoors when I am working close to a subject and can't move back; without a diffuser, the bounced light can look too top-heavy in this situation.

However, I still want a measure of control over where I direct my light. Therefore, I cut a hole in the top of a Stofen so that the majority of light can still be thrown in a direction of my choice, instead of being scattered all around. (I do keep a spare Stofen on hand that is unblemished.)

These diffuser cups do come in handy for specific uses; I recommend that any photographer who uses flash have one of these handy in the camera bag. However, there are some things to keep in mind with these diffusers. Most importantly: they do not soften light, per se. They scatter the light, but that does not, in and of itself, give you softer light. The reason for this is that your light source is pretty much the same size with or without the diffuser cup (when shooting with the flash directly forward). To get softer light, you need to have a *larger* light source in relation to your subject and taking distance into account. (For

The only other light modifier that I use is a Stofen Omnibounce . . .

example, the sun is a phenomenally large light source. But, because it is a zillion miles away it acts as a pinpoint light source, producing harsh shadows.)

Your flashgun is a small light source, and will therefore give harsh shadows if you just shoot directly without any thought. The only way to get softer light from a strobe is to make your source of light larger—either via an umbrella or diffuser panel, or by bouncing the light off a wall or a similar surface.

If you're using the diffuser cup indoors and bouncing your flash, the light from the strobe is scattered and bounces back from the walls and ceiling. That makes the flash light appear a bit softer. However, too much light is still coming directly from the strobe head itself, and that is why it will very often look harsher than flash bounced entirely off other larger surfaces.

> **The diffuser cup can be useful in forcing light falloff to the foreground.**

Outdoors, using the flash with a diffuser cup makes very little sense—except when you need a wider spread of your strobe light because you're using a wide-angle lens. The diffuser cup can also be useful in forcing light falloff to the foreground. When you're taking photographs outside at night, for instance, and the flash is the dominant source of light, you might want to use a flash modifier and the flash at 45-degree tilt so that the foreground is lit only by the light feathered from the flashgun (*i.e.,* purposely not exposed properly). Bouncing your flash upwards when outdoors is just crazy, since there is nothing to bounce the flash off. You're just wasting your batteries and shortening the lifespan of your speedlight by unnecessarily dumping a lot of charge every time.

Adapting Techniques for Modifying Flash

Don't be afraid to experiment and adapt your technique to match different situations. Even though I have a preference for bouncing my flash with the black foam half-snoot as described, there is a severe limitation to doing it that way: it uses a lot of battery power. Quite often there just isn't enough juice in the

PLATE 9-14. This image shows the setup of the room in which we were working.

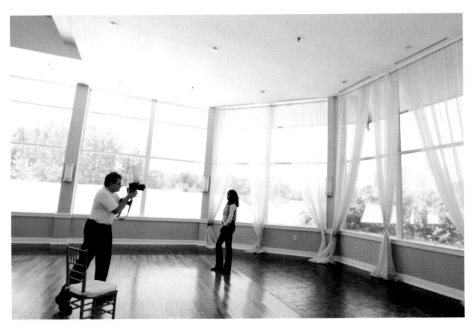

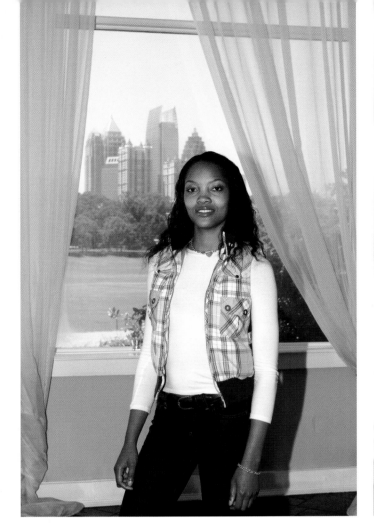

speedlight to light up a large room. This following sequence shows the progression in getting to the results I wanted, which was to show the model against the city in the background.

Plate **9-15** shows that, at ⅓₀₀ second at f/8 and 200 ISO, we get the foreground and background nicely balanced in exposure. However, the direct flash isn't flattering and there is the hard shadow from the direct on-camera flash. This isn't ideal.

Bouncing the flash behind me to soften the light, as seen in plate **9-16**, gave a sequence of underexposed test shots—until I finally arrived at the settings shown. Here, there was enough flash on the model (with a fair amount of available light contributing), to give correct exposure. The lighting on her is now flattering, but we're losing the background completely.

For the final image (plate **9-17**), I attached a white card to the flash to throw some light forward while bouncing a lot of light from my flash. You could either make your own or use Better Bounce Card; it would work very well in this situation as well. Check the web site at www.abetterbouncecard.com. Instead of now spilling most of the light from my flash into the room, I was sending most of the light forward and upward from the camera's viewpoint. This was a more efficient use of the flash and still gave soft enough light from my speedlight to be flattering.

PLATE 9-15 (LEFT). The first image was created using direct flash. Notice the harsh shadows. (SETTINGS: ⅓₀₀ second, f/8, 200 ISO; FEC –0.3 EV)

PLATE 9-16 (RIGHT). In this image, I bounced flash behind me into the room. (SETTINGS: ⅓₀₀ second, f/2.8, 200 ISO; FEC 0 EV)

PLATE 9-17. The final version was created using a white card reflector on the speedlight. (SETTINGS: $\frac{1}{300}$ second, f/5, 200 ISO; FEC +3.0 EV)

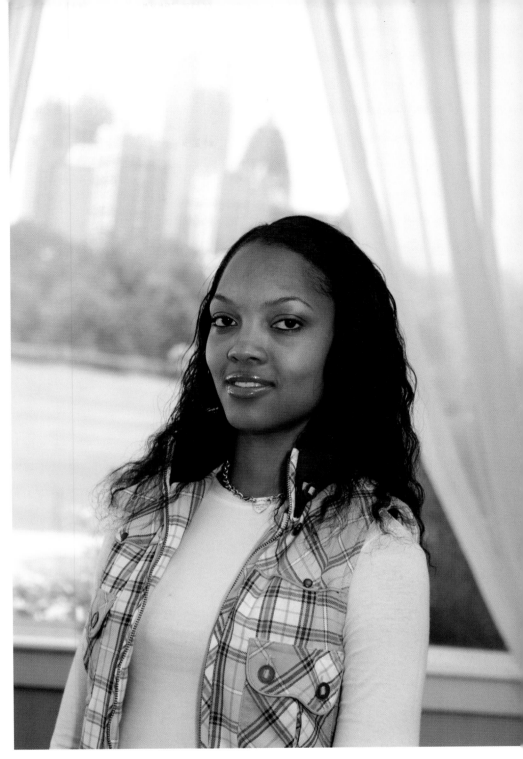

I achieved correct exposure by doing a series of test shots . . .

I achieved correct exposure by doing a series of test shots in which I allowed the flashgun to give me maximum output. Through these, I found an aperture where I had correct flash exposure. The speedlight gave me maximum output in this situation because I had dialed the FEC (flash exposure compensation) to maximum. (Switching to manual output on my flash would have given me similar results for this image.) I now had an aperture of f/4.5, which gave me correct exposure on my model for the way I was now diffusing my flash's light. This aperture also gave enough detail in the background to make for a pleasant balance between it and how my model was lit.

10. Bounce Flash

Our objective when using flash, even from an on-camera speedlight, is to make the light from the flash appear as natural as possible—or at the very least, not to make it obvious that flash was used. Ideally, we will seamlessly blend it with the available light. While that may not always be possible, it should always be what we are striving for. In using flash wisely, we are primarily concerned with the direction of the light from our flash, followed closely by the amount of flash in relation to our ambient light, and the color from our flash in relation to the ambient light.

Avoid Direct Flash (When Possible)

Direct flash is, for the most part, the least attractive way to use flash. Any time our subject can see our flashtube (or light modifier) there will be direct flash on them. For the most part, this will be something we will try to avoid.

Indoors, we can get much better results by bouncing our flash off of various surfaces. When we do this, the area that we're bouncing flash off (not the speedlight itself) becomes the main source of light—and the larger the light source, the softer the light.

Outdoors, we're usually compelled to use direct flash to lift the shadows and reduce the contrast. Still, we can try to overcome these obstacles by looking for surfaces to bounce our flash off, or by having a helper hold up a reflector that we can bounce flash off.

Indoors, we can get much better results by bouncing our flash off of various surfaces.

Avoid Flash Shadow

The amount of flash we use can vary from subtle fill flash to control contrast all the way up to an output sufficient to overpower the ambient light. The trick here is to avoid all signs of a discernable flash shadow. A distinct hard flash shadow is a dead giveaway that we used flash; it looks very unnatural. This is a very important point that I would like to stress. Even though an on-camera speedlight was used for all the images in the book, there is no discernable flash shadow to be seen in any of them. (I also want to point out that the images in this book had very little Photoshop fairy dust sprinkled on them. The intention here was to show how good the images can look simply through skillful use of flash.)

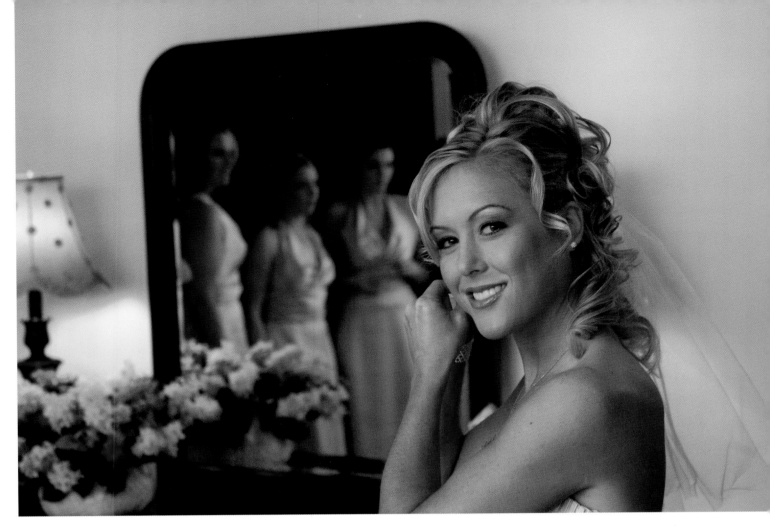

PLATE 10-1. On-camera flash was bounced to provide directional light on the bride. Enough light also bounced around the room to light the bridesmaids. (SETTINGS: 1/80 second, f/4, 640 ISO; FEC +0.7 EV)

Controlling the Direction of the Flash

We need to consider the direction of our light carefully. This is one of the areas in which we can really set ourselves apart as photographers; when we carefully choose the direction from which our light falls onto our subject, we can control the mood of the photograph completely.

Most often, when photographers start using their flashguns out of the directly forward position, they move the flash head to point 45- or 90-degrees upward. The idea here is to bounce flash off the ceiling. Even though, in most cases, this is an improvement over using the flashgun pointing directly forward, it is not ideal. We can improve on this.

If we consider how studio lights are set up, we'll rarely see a main light source directly above the subject's head. Top lighting just isn't as flattering as light coming in from an angle to the subject. So why would we want to bounce our flash directly overhead of our subjects?

In the bridal portrait seen in plate **10-1**, the directional light coming in from the side gives depth to the image and creates modeling on the bride's face. Note, again, how the bride is lit from the *side*; there is no light falling directly onto her from the camera's viewpoint. By bouncing my flash over my left shoulder into the ceiling behind me, enough light also spilled into the room to light the bridesmaids standing in the doorway.

Practical Examples

We have to think of the area that we're bouncing light off as our light source. Let's look at some real-world examples. The images in this section were all taken using a single on-camera flashgun. Notice how, by bouncing the flash, I was able to create soft, directional light that looks completely natural.

Looking at plate **10-2**, note that there is no light directly from the camera's viewpoint. Therefore, instead of a flat, even light, we have directional light. Light is coming in from the side and creating that interplay between light and shadow that gives shape and dimension to our subjects.

The exact way that flash was bounced here was by swiveling the head 45 degrees to the camera's left, then tilting it about 30 degrees up. To stop any direct flash from falling onto the bride, I had to block the flashtube a little bit. In this instance, I used my left hand, but I often use a piece of flexible foam for this. Because I shielded the direct light from her, the only light source was from above and slightly behind our bride. Essentially, we are mimicking the effect that a large softbox set to the left of the camera would have given us.

Let's look at a closeup image created in this same setting (plate **10-3**). Again, I did not bounce light off the ceiling or even behind us. Bouncing the light off the ceiling would have produced a "raccoon eyes" effect. Bouncing light behind us would have

PLATE 10-2 (TOP). By bouncing the flash off a nearby wall and ceiling (and blocking the direct light from hitting the bride), a soft, appealing portrait was created. (SETTINGS: ¹/₁₀₀ second, f/3.5, 500 ISO; FEC +0.7 EV)

PLATE 10-3 (BOTTOM). The catchlights reveal the position of the main light. (SETTINGS: ¹/₂₅₀ second, f/3.5, 500 ISO; FEC +0.7 EV)

PLATE 10-4. Turning the flash off allowed me to create an entirely different look—and to show you the ambient light setting for the previous two images. (SETTINGS: 1/80 second, f/3.5, 500 ISO; no flash)

It's possible to create flattering portraits with a minimum of fuss.

produced light that was too flat. As in the previous image, no flash modifier was used (aside from my hand blocking the light). Any other light modifier would have thrown too much light forward, spilling it directly onto the bride's face—an unflattering look. By being very specific about the direction of the light source, it's possible to create flattering portraits with a minimum of fuss.

Also, note that the higher shutter speed used to create the second image caused the out-of-focus areas in the background (a window lit by daylight) to record much darker than in the first image. Just how much flash was used, and how it was balanced with the available light, can be deduced from the next image (plate **10-4**). In this image, created in the same setting, I didn't use flash at all. Instead, I used only the available light to create a silhouette effect. The same camera settings were used for this image as for the images above, so you can see how using flash wisely made all the difference.

In the next image (plate **10-5**), all the light was from an on-camera flash. By shielding the light from the flash head with my hand I was able to direct all the light to the wall behind her. This gives the effect of light from a large window behind her—or a large softbox. Note how the light wraps around the bride. If I had chosen to use a generic light modifier, I wouldn't have been able to direct my light the way I intended. I would've thrown too much light directly on the bride's bouquet and dress. If I had bounced the flash from the ceiling, I would have had flat lighting as well.

Similarly, with this detail shot of a wedding cake (plate **10-6**), I chose to bounce the light off the wall to the camera's left. The texture and detail of the cake's decorations were revealed by this type of side lighting. Because the light falloff is gradual with the curve of the cake, it created a nice sense of depth. Any form of direct flash (even from a light modifier) would have negatively affected the delicate light. The slow shutter speed was to allow more of the ambient light in, which is visible in the background.

PLATE 10-5 (BELOW). I used my hand as a simple modifier to direct the light at the wall behind the bride. (SETTINGS: $\frac{1}{80}$ second, f/6.3, 500 ISO; FEC +0.7 EV)

PLATE 10-6 (FACING PAGE). Bounce flash helped reveal the texture of this cake. (SETTINGS: $\frac{1}{25}$ second, f/5.6, 800 ISO; FEC +1.0 EV)

The next image (plate **10-7**) illustrates that you do not need a white wall or ceiling to bounce flash from. Here, I bounced flash away from me to my left and up into the limo's black leatherette interior. Because the black surface did not reflect much light back, the ISO setting was fairly high and a wide aperture was used. Just enough light spilled back from the leather to help light the bride.

It should be apparent now that directional light gives form and dimension to our subjects. Couple that with the idea that softer light tends to be more flattering, and it makes sense to bounce our flash from the side—off some other surface—instead of using flash directly. Using this technique, we can consistently use on-camera flash to create images that have beautiful, soft lighting—and lighting that looks very flattering.

PLATE 10-7. With a high ISO and wide aperture, there was just enough bounce from the limo's black leatherette interior to help illuminate the bride. (SETTINGS: 1/40 second, f/4, 1000 ISO; FEC +1.0 EV)

Bounce Flash in Relation to the Background

Adding flash gives us more control over the lighting of our subject in relation to the background. In doing so, however, the flash need not substantially alter the look of the photograph.

For this simple portrait (plates **10-8** and **10-9**), I wanted to illustrate how I could control the background's brightness by changing my settings, while allowing TTL flash to light my subject. I bounced my flash to the left of me off the window and part of the wall. I also made sure to shield my flash head so that only *indirect* light fell onto the model's features. Because I chose my direction carefully, the flash didn't really affect the mood of this window-lit portrait. The change in aperture (seen in the second image), however, definitely affected my ambient light. This gave me more detail and color in the background.

The flash need not substantially affect the look of the photograph.

PLATE 10-8 (TOP LEFT). In this portrait, taken with window light only, the background is overexposed. (SETTINGS: 1/250 second, f/2.8, 800 ISO; no flash)

PLATE 10-9 (TOP RIGHT). Carefully adding flash maintains the mood of the image and allows the background to be recorded with more color and detail. (SETTINGS: 1/250 second, f/4.5, 800 ISO; FEC +0.3 EV)

PLATE 10-10 (LEFT). Here, the positions of the camera, flash, and subject are seen.

Plates **10-11** and **10-12** were created in a restaurant in Brooklyn, overlooking the Manhattan skyline. The interior of the restaurant was dimly lit and, even with the rainy early evening skies, the outside was brighter than inside. Using my on-camera flash, I had to balance the two areas. Plate **10-11** shows my ini-

PLATE 10-11 (LEFT). My initial test shot was made using only the ambient light and metering for the outside.

PLATE 10-12 (BELOW). Adding flash brought the interior and exterior scenes into balance. This image was shot on a Canon 1D Mark II camera with a Canon 16–35mm f/2.8 lens. (SETTINGS: 1/15 second, f/4, 800 ISO; FEC +0.7 EV)

PLATE 10-13. Bounce flash from an angle added dimension to this image and helped balance the interior and exterior light levels. (SETTINGS: $^1/_{160}$ second, f/4, 1250 ISO; FEC +2.3 EV)

tial test shot made using only the ambient light and metering for the outside. I then added flash by bouncing the flash off the ceiling behind and to the right of me. This showed me that I needed to add some flash exposure compensation—and +0.7 EV looked about right. Even though the shutter speed was low for the final image, I wasn't too concerned with camera shake, because the piano player would be too dark (without flash) for camera shake to be noticeable if I handled my camera carefully. In comparison with the test image, you can clearly see the effect of the added flash (plate **10-12**).

In the scene shown in plate **10-13**, there were extreme differences in brightness between the interior and exterior. To compensate, I used flash to light the interior. I bounced the flash away from me, upward to my right, flagging it so that there was no direct flash on the couple. This allowed the light to come back at an angle, giving shape and form—unlike what it would have looked like if the flash were more direct from the camera front. I chose a high shutter speed so that it was easier to match the flash exposure with the very bright light outside.

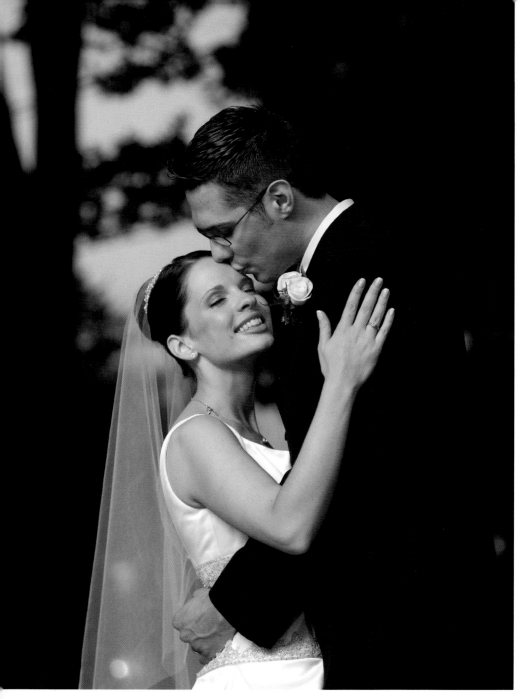

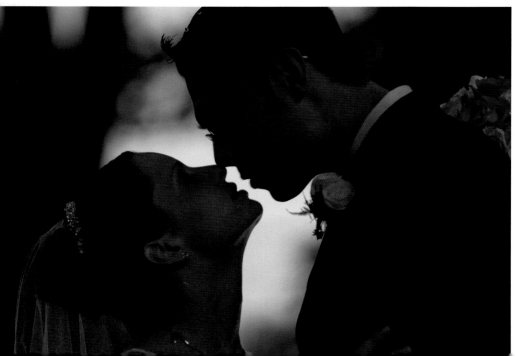

PLATES 10-14 (TOP) AND 10-15 (BOTTOM). In a backlight situation like this (left), even if the flash doesn't fire, an attractive silhouette image is produced (bottom). My settings were specifically chosen so that the evening sky would register. (SETTINGS: $\frac{1}{20}$ second, f/2.8, 1250 ISO)

PLATE 10-16 (TOP). Bouncing flash off to the side, to my right, allowed the light to come in at an angle, diffuse and soft. So, even though flash was used, the lighting is such that the romantic mood is retained. (SETTINGS: $1/50$ second, f/4.0, 1600 ISO; FEC +0.3 EV)

PLATE 10-17 (BOTTOM). The light levels at this tented reception were too low to make shooting with only the existing light a viable option. With a white canvas tent, it is simple enough to get flattering, soft light with flash: turn the flash head around and bounce the flash behind you. (SETTINGS: $1/30$ second, f/3.5, 1600 ISO; FEC +1.3 EV)

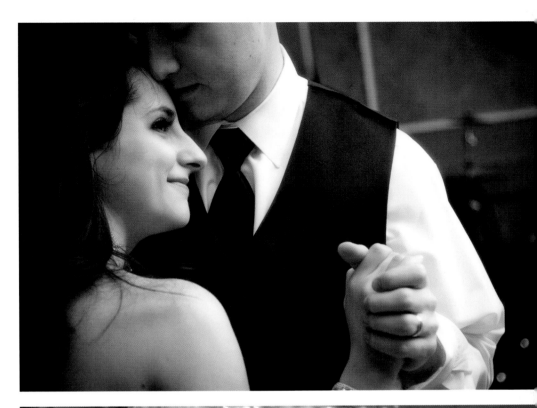

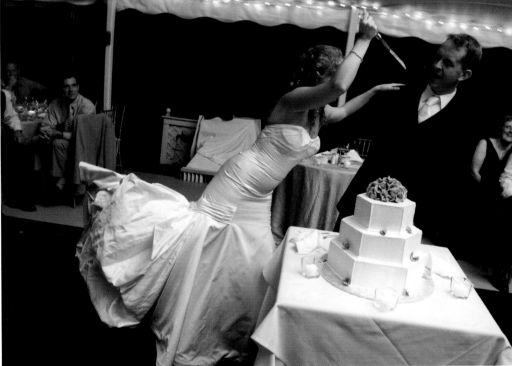

In positioning my subjects, I often place them against a brighter background, then use flash to illuminate them. To create plates **10-14** and **10-15**, I placed my couple against the last bit of blue in the evening sky, then bounced flash off the high porch ceiling to illuminate them. Because of the way I positioned them, even if the flash did not fire (for example, if I were shooting faster than the battery pack would allow) I would still get a beautiful silhouetted image.

Checking Your Results

Not having a sufficiently large light source will have a negative impact on your images, as seen in plate **10-18**. During the receiving line, I was backing up closer and closer to the wall to grab candid portraits of the bride and groom greeting their guests. I was bouncing my flash up and behind me, off the wall and ceiling. As space was limited, I was eventually backed right up against the wall. As a result, instead of bouncing flash off a large surface, my flashgun was a few inches from the wall. This had the effect of giving me light from a small light source, which means harsher light. In this candid portrait of the groom, you can see the effect of having my flash bounce off a small surface; there is a pronounced shadow, almost as if I had used direct flash. You can also see the specular reflections on his skin—all due to using bounce flash improperly. Fortunately, because I was shooting with a digital camera, I was quickly able to catch this on the LCD and correct how I was using my flash—simply by moving away from the wall.

This is why I don't think that chimping (checking your LCD preview) is a bad thing. I am constantly keeping an eye on my LCD while I'm shooting—it gives me the opportunity to observe and correct small issues before they become a problem. On the spot, you can adjust your settings and how you bounce your flash to improve the resulting image.

Here's another example. When shooting the bride-and-groom image seen in plate **10-19**, I realized that my flash head wasn't turned away completely from the couple; looking at my LCD screen, the blue-tinted specular reflection on the wall and mirror was a dead giveaway. So, I simply turned the head of my flash a little further behind to the left of me, eliminating the harsh glare and creating a far more natural light with my flash (plate **10-20**).

PLATE 10-18. When you're too close to the bounce surface, your lighting will be compromised. Harsh shadows and specular reflections on the skin are clear in this image.

PLATE 10-19 (RIGHT). Looking at my LCD screen, I noticed the glare on the left side of the image.

PLATE 10-20 (BELOW). I quickly readjusted the direction of my flash to create a more natural look. (SETTINGS: $^1/_{125}$ second, f/1.4, 1000 ISO; FEC 0 EV)

Balancing Bounce Flash with Ambient Light

In the next sequence of images, I want to show how adding flash opens up the image and gives a cleaner light than just the available light would. The complete effect is seen in the first image (plate **10-21**).

The second image (plate **10-22**) shows what just the available light, photographed at the same settings, would have looked like. As such, this photo is underexposed; this is where the use of flash lifts the exposure up to the correct levels.

When flash is only used as fill, it is necessary for us to expose properly for the ambient light. But in a situation like this, where the ambient light and flash appear in (more or less) equal quantities, the overall exposure needs to be correct. In other words, the ambient light and the flash added together need to be enough to give correct exposure. Where the flash is more dominant as a light source, we don't need the ambient light to be correctly exposed. However, the ambient light was taken into consideration in getting to the final image.

PLATE 10-21. Flash was used to open up the lighting for this image. (SETTINGS: $^1/_{125}$ second, f/3.5, 1000 ISO; FEC 0 EV)

The final image (plate **10-23**) is a pull-back shot to show the entire area. I bounced flash (which was gelled by a ½ CTS), to my right and slightly upward, using the black foam half-snoot. In this manner, I directed the light from the flash to fall in at an angle to the setting seen in the first image. As a result, the lighting is very even from back to front.

PLATE 10-22 (TOP). Eliminating the flash results in underexposure. (SETTINGS: $^1\!/_{125}$ second, f/3.5, 1000 ISO; no flash)

PLATE 10-23 (BOTTOM). A pull-back shot showing the entire area.

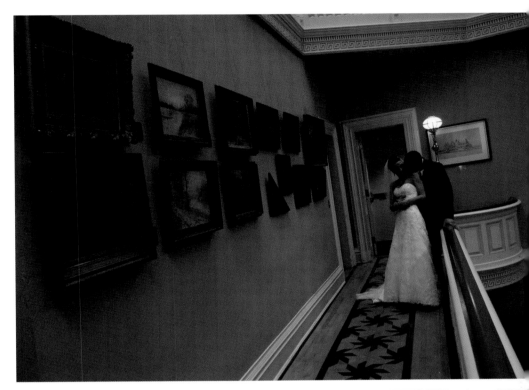

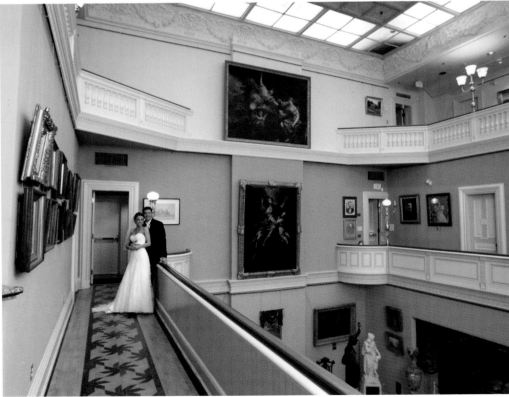

PLATE 10-24. Here, the flash was bounced to my left. As a result, the part of the model's face that was more open to the camera was lit directly with bounce flash. This resembles broad lighting.

PLATE 10-25. Here, the flash was bounced directly behind me. Even though the light from the flash is soft, it lacks dimension. This is the least interesting way to use your flash in this instance.

PLATE 10-26. Here, the flash was bounced to my right. As a result, the part of the model's face that was less open to the camera was lit directly with bounce flash. This resembles short lighting. It is a slightly more dramatic way of lighting the model's face and, here, the more flattering way to use light from our flash.

Broad Lighting and Short Lighting

In classic portraiture, there are a number of ways to light portraits. The two of the most familiar ways are short lighting and broad lighting. With short lighting, more light is placed on the side of the subject's face turned away from the camera (the narrower side of the face from the camera's perspective). With broad lighting, more light is directed onto the side of the face turned toward the camera (the wider side of the face from the camera's perspective). With studio lighting, whether in the studio or on location, this can be finessed to a remarkable degree. With just on-camera flash, however, we can only approximate this kind of lighting. Still, we can have a surprising amount of control over how simple portraits are lit with just an on-camera flash. In this illustrative sequence (plates **10-24** to **10-26**), I bounced flash in different directions, and you can clearly see how this affected the final look of the portrait.

As you can see, how seamless our bounce flash looks depends largely on us being aware of the ambient light—and the direction of the ambient light—and then adding flash to it. This can be as fill, as a main source of light, or somewhere in between. We can finesse our results by consciously choosing the direction in which we bounce flash. We can add to the ambient light, or we can bounce from an opposite direction to lift the shadows a bit. Any way we decide on it, the image will look better if we put some thought into it, instead of shooting direct flash—or, just as bad, choosing a default 45-degree bounce angle when it isn't appropriate.

We can have a surprising amount of control over how simple portraits are lit . . .

11. Flash with Tungsten Ambient Light

The color temperature of the speedlight is around 5400K. While the actual number value might have little meaning to many photographers, it does mean that light from a flashgun will look a lot cooler than the tungsten/incandescent light does. That warm glow of tungsten light, which is around 2800K but varies a lot in actual value, makes the flash appear too cold, or too blue. However, if you simply adjust your white balance so that the flash appears neutral, your background will go a murky orange.

Adding Gels

We can reduce this effect by filtering the strobe in a number of ways. Adding a full CTS filter brings the color temperature of the strobe down to 2900K, while a ½ CTS gel converts flash to 3800K (and other CTS values are available for different color-temperature values). A CTO gel can also be used to bring the color temperature down to 2900K, but this has more red than a CTS gel and can make it more difficult to get full range of colors in your image. A ½ CTO converts flash to 3800K. Nikon strobes are supplied with a gel that converts the light's color temperature to balance with tungsten lighting.

I would recommend the CTS gels since, in my experience, it is easier to get a nice skin tone from them than with the CTOs. They can be ordered in rolls from any of the major photographic supply stores and are inexpensive. If you filter your flash like this, you will also need to change the white-balance setting on your camera to either 2800K or tungsten. It would still be necessary to adjust your white-balance even further as part of a normal RAW workflow, since you will most likely have bounce flash causing the light from the flash to change color.

Light Modifiers

Some flash modifiers, such as the Stofen Omnibounce, also offer a solution for warming up your flash by bouncing it off a warm-toned surface. Using the gold Omnibounce results in light with a 3800K color temperature, for example.

Some flash modifiers also offer a solution for warming up your flash . . .

However, using a ½ CTS gel with a white Omnibounce (or other modifier) might be a better solution. Both ways give the same color temperature, but using the gel with the *white* modifier allows you to pop the modifier off as needed (to get better bounce flash) without the flash's color temperature changing as it would if you decided to remove the gold Stofen. This results in more consistent images and an easier postproduction process.

PLATE 11-1. Gelling the flash to match the ambient light helped produce a seamless look. (SETTINGS: ⅟₆₀ second, f/4, 1600 ISO; FEC 0 EV)

Practical Examples

In plate **11-1**, the groom, waiting for his bride to come down the aisle, was standing under a tungsten spotlight. To counter this and add some light to his features, I half-snooted my flashgun with black foam and gelled my flash for tungsten light. In this instance, I used a full CTS gel taped to my flash head. I also rotated my flash to point 90 degrees to my right, away from my subject, and swiveled it 60 degrees upward. This meant that all the flash falling onto the groom (and groomsmen) was indirect. If you look at the light on the groom's

face, you'll notice there is no light coming directly from the camera's viewpoint; it's all indirect, directional light.

Once again, I wasn't bouncing off a wall, but instead blasting flash into the ceiling away from me. The light that spilled back was enough to light the groom and some of the groomsmen. My shutter speed was chosen so that there was a balance between the ambient (tungsten) light and my flash.

Another important thing to note is that, even though I used flash (which is a colder light) and the ambient light was tungsten (which is a much warmer light), the color doesn't change much as the light from the flash falls off to the background. This is because I gelled the flash to match the ambient light.

In the church seen in plate **11-2**, there were numerous spotlights on the stage lighting the bridal party and minister. The couple, however, was in an area that was more shaded than the stage, so I had to use flash to light them. I used the tungsten filter that comes with the Nikon SB-800 speedlight for this. The filter brought the flash's color balance close to that of the ambient tungsten light, giving a more uniform color balance to the image. I also used the Nikon flash diffuser that comes standard with the SB-800, since there wasn't a low ceiling to bounce the flash off and I needed to throw a fair amount of flash forward to light the couple.

PLATE 11-2. A Nikon gel and diffuser balanced and softened the direct light from the flash. (SETTINGS: 1/60 second, f/4, 500 ISO; FEC +0.3 EV)

For the next image, plate **11-3**, I fitted my flash with a full CTS filter, giving a neutral color balance compared to the rest of the lighting in the venue and the videographer's light—all of which were incandescent. My camera's white balance was therefore set to tungsten, and I further fine-tuned the color balance as part of my postproduction workflow.

Although it may not look like it, the following two images (plates **11-4** and **11-5**) were taken during the reception at an Orthodox Jewish wedding—and these shots are typical of the general delighted craziness going on during these events. Both images were taken using a 16–35mm f/2.8 zoom lens, with the flash bounced behind me—not *directly* behind me, but over my shoulder. I used the black-foam half-snoot to direct my light. The flash was also gelled for the predominant ambient light, which was tungsten.

Bouncing my flash as I did made the immediate foreground and the background fairly evenly lit. This is because my light source was, effectively, a large part of the ceiling behind and to the side of me. Therefore, the distance from my light source to my subject and the background was not such a huge jump.

Just as important is that I filtered my flash for tungsten. This resulted in there not being a falloff in color balance from the foreground to the background as the impact of the light from my flash receded. If I hadn't filtered my flash, there would have been a pronounced jump in color balance from cold to warm. (Or,

PLATE 11-3 (ABOVE). A full CTS gel helped balance the flash with the ambient light and the videographer's light. (SETTINGS: 1/100 second, f/2, 1600 ISO; FEC +0.7 EV)

PLATES 11-4 AND 11-5 (FACING PAGE). Gelled bounce flash provided even, balanced lighting for these reception images. (SETTINGS: 1/125 second, f/4, 1600 ISO; FEC +0.3 EV)

PLATE 11-6 (TOP LEFT). Thoughtful use of flash helped retain the pub's atmosphere in this portrait. (SETTINGS: $\frac{1}{60}$ second, f/1.8, 1600 ISO; FEC +1.3 EV; flash gelled with $\frac{1}{2}$ CTS)

PLATE 11-7 (TOP RIGHT). This is how the ambient light alone looked at the settings I chose to use.

PLATE 11-8 (LEFT). With this portrait, I had to shield my flash so that the light falling on the model(s) was quite directional and would give the appearance of being from one of the pub's lamps. I used the black-foam half-snoot as my flash modifier. It also helped prevent the flash from producing any noticeable hot-spots on the wood paneling in the background.

if I had corrected for the areas lit by flash, there would have been a change from neutral to unpleasantly orange toward the background.)

Photographing in a pub (plate **11-6**), I wanted to retain the atmosphere and not kill it with flash. In order to do so, I decided to gel my flash with a ½ CTS filter and set my camera's white balance to 3800K. Even then, I had to finesse the color balance when postprocessing the images in my RAW conversion program. This was because I had to bounce my flash off part of the wall and ceiling in this pub, which were far from being a neutral color. In the pull-back photograph (plate **11-8**), you can see the interior of the club and the areas I bounced the flash off.

In plate **11-9**, created during the same session, I positioned myself in relation to the models so that the little bit of available light sneaking in through the blinds (outside of the camera's viewpoint), would give a rim light on his face, separating him from the background. Then I used flash, bounced off the ceiling and wall to my right, to create directional lighting on the couple.

In some cases, I want to let the background go warm and don't gel for the incandescent light. That was the case with the portrait of the bride and groom

PLATE 11-9 (LEFT). Flash and ambient light were both used selectively to create this image. (SETTINGS: ¹⁄₄₀ second, f/2.8, 1600 ISO; FEC +1.3 EV; flash gelled with ½ CTS)

PLATE 11-10 (RIGHT). This comparison photo shows the available light and makes it apparent what component of the light was flash.

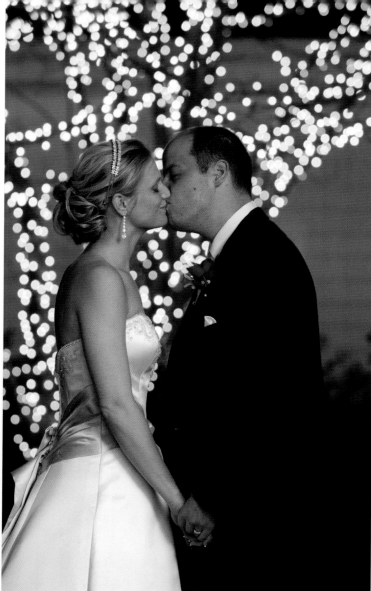

seen in plate **11-12**. I positioned the couple outside in front of the tree lit with holiday lights. I bounced the flash off the side of the building to give softer lighting. The test shot (the silhouette seen in plate **11-11**) also worked very well, but it wasn't the ultimate image I wanted to create.

As noted earlier in this chapter, I normally choose either the CTS or the ½ CTS gel when working inside where incandescent (tungsten) lighting dominates. The choice between the two is based primarily on whether I want my background neutral (CTS filter with the camera's white balance set to tungsten), or whether I want my foreground and subjects neutral with a background that is pleasantly warm (½ CTS gel and the camera's white balance set to 3800K.) Sometimes, when the tungsten lighting is mild and there is a fair amount of daylight from large windows, I will prefer a ½ CTS gel instead of a full CTS.

The approach here isn't one of precision, but one of bringing the flash's color temperature closer to that of the ambient light when it is predominantly tungsten lighting.

PLATE 11-11 (LEFT). Here, you see the scene with the ambient light only.

PLATE 11-12 (RIGHT). With the addition of bounce flash, the tones are rendered normally and the background retains a golden glow. (SETTINGS: 1/60 second, f/4, 800 ISO; FEC +0.3 EV)

Improving Uneven Lighting

In the illustrative sequence of images seen in plates **11-13** through **11-15**, I deliberately placed my model under a spotlight in the ceiling to show how to deal with a specific lighting problem. Normally, we would try to position our subjects so that we don't have to deal with this kind of harsh, uneven light. If you cannot move your subject, though, here is how to work with this kind of lighting situation with an overhead tungsten spotlight (plate **11-13**).

By bouncing flash off to the side of me, toward my left and slightly over my shoulder, I was able to lift the shadow areas completely, evening out the light (plate **11-14**). I did gel my flash here—in this case, adding a piece of ½ CTS gel taped over my flash head. This filters the bluish light from the speedlight to approximately 3800K, closer to the color temperature of incandescent light. The color temperature of my flash will not actually be exactly 3800K, though, because I bounced the flash off a non-white surface, which also changes the color. (Correcting for this to get to a pleasing skin tone should be part of your RAW workflow.)

PLATE 11-13 (TOP LEFT). Here we see the image with the available light only—a tungsten spotlight over the model's head.

PLATE 11-14 (TOP RIGHT). Adding gelled flash creates a much more attractive lighting pattern and a nice color balance with the existing light. (SETTINGS: ⅟₈₀ second, f/3.5, 1000 ISO; FEC +0.7 EV; flash gelled with ½ CTS)

PLATE 11-15 (BOTTOM LEFT). Here is the same model but with the light from the flash not gelled. You can immediately see that there are areas of skin tone that are blue and other areas that are yellow. This isn't as pleasant-looking a skin tone as was achieved with the flash gelled.

PLATE 11-16 (BOTTOM RIGHT). Moving the subject out of the direct overhead light and using bounce flash to illuminate her produces still better results. (SETTINGS: ⅟₁₀₀ second, f/1.4, 800 ISO; FEC +0.7 EV; flash gelled with ½ CTS)

In comparison, plate **11-16** (previous page) shows how I would ideally handle this straightforward portrait—by placing my model away from the overhead light, then using bounce flash to create soft and directional light on her.

A few more images from this sequence will show how flash that is gelled for tungsten (in this case, again, with a ½ CTS filter) will help in giving a natural look to our lighting.

The first image (plate **11-17**) shows the quality of the available light in this scene; it is uneven and with darker areas around the eyes. The idea here is to show the quality of the lighting, and not so much an indication of the available light exposure. I purposely set my camera so that the available light would give an underexposed image, allowing me to improve the results by adding a touch of gelled flash. (Obviously, if I had decided not to use flash, I would have changed my settings to give correct ambient exposure.)

PLATE 11-17. This image shows the ambient light that was incorporated into the final image.

PLATE 11-18. Bounce flash from the side produces soft, directional light. (SETTINGS: ¹⁄₁₀₀ second, f/1.8, 800 ISO; FEC +0 EV; flash gelled with ½ CTS)

PLATE 11-19. The challenge here was hiding the photographer and the camera—and not creating visible hot-spots from the area the flash was bounced off. (SETTINGS: $1/50$ second, f/2.8, 800 ISO; FEC +0.7 EV; flash gelled with $1/2$ CTS)

The solution here was to bounce my flash off the wall to my right-hand side.

Adding directional bounce flash on our model, the light on our subject opens up and gives a flattering portrait. Once again, our light is coming from the side, giving form to our model's face in a way that flash bounced from directly overhead would not have (plate **11-18**).

For the next example (plate **11-19**), I placed the model in front of a mirror. What made this seemingly simple portrait very tough was that I had to hide my own reflection behind the model. I also had to make sure my camera and flash didn't peek out. Additionally, I needed to make sure that the area that I bounced flash off didn't appear in the frame; otherwise I would have gotten an unpleasant hot-spot on the ceiling or wall. The solution here was to bounce my flash off the wall to my right-hand side, completely out of frame. This meant the model and setting were evenly lit, without it being immediately apparent where I bounced my flash. Since the light was coming in at an angle to the model, I also got pleasantly soft and directional light on her.

12. Using Flash to Control Contrast

In many cases, flash will be used as your main light source. However, it can also work well as a fill source, helping you to control the contrast in your scenes and on your subjects. When doing so it's important, again, to maintain a good relationship between the ambient light and the flash. If you do so, the image will look very natural—almost as if flash was not used at all.

Practical Examples

With the bridal portrait seen in plates **12-1** and **12-2**, I wanted to show how you can use flash to control the contrast of a scene without having the flash substantially change the look of the image. In the first image (plate **12-1**), the bride was photographed using only the ambient light. The image is nice, but notice the exposure on the background and curtains. By adding flash, and raising the shutter speed to ¹/₂₅₀ second (the maximum flash-sync speed), I was able to bring down the ambient exposure by more than a stop in comparison to the first image (plate **12-2**). This retains more detail in the curtains. The bride would have been underexposed if I hadn't used flash to bring up the exposure on the inside.

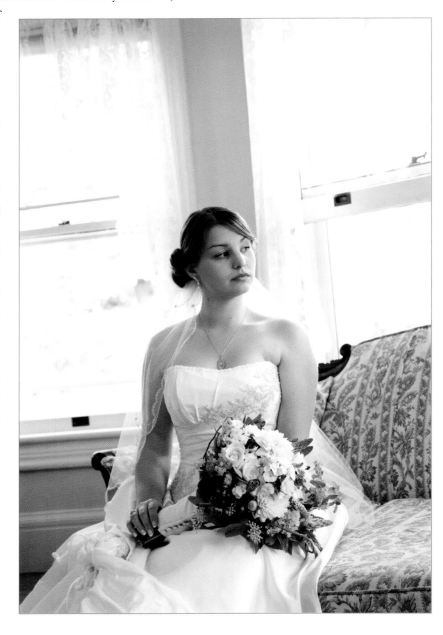

PLATE 12-1 (RIGHT). With the ambient light only, the scene contrast was too high to maintain optimal exposure on both the bride and the background. (SETTINGS: ¹/₈₀ second, f/4, 1000 ISO; no flash)

PLATE 12-2 (FACING PAGE). Adding flash helped reduce the contrast between the bride and the background. (SETTINGS: ¹/₂₅₀ second, f/4, 1000 ISO; FEC +0.7 EV)

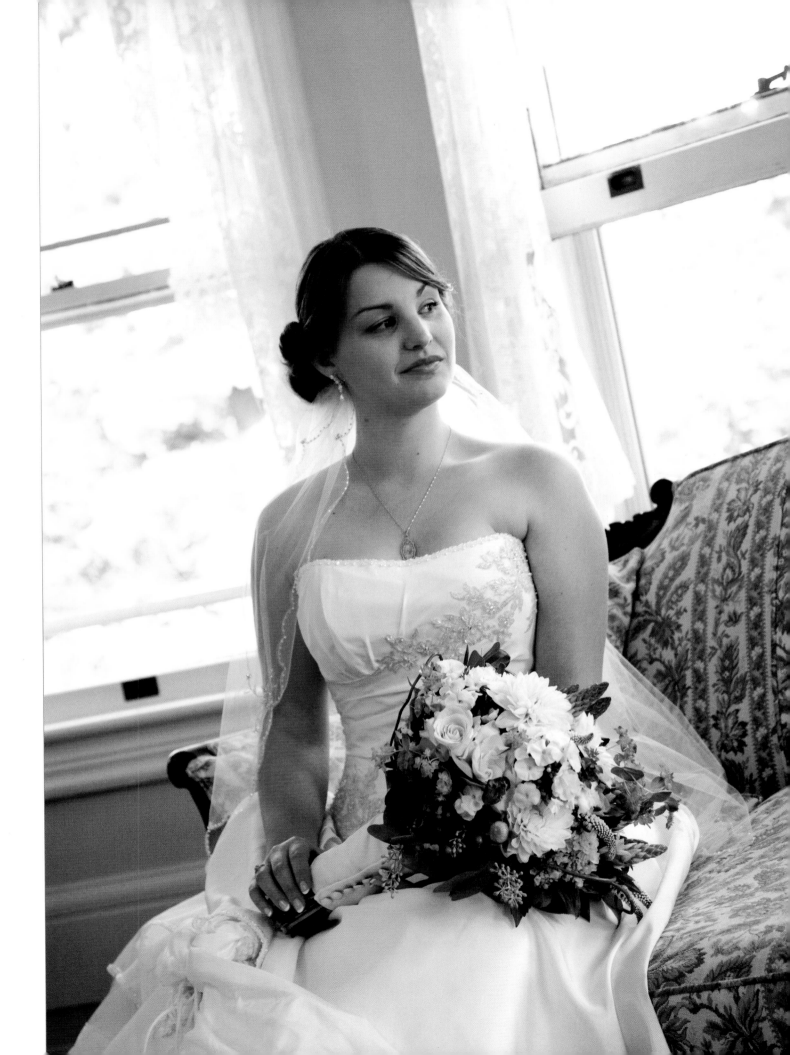

Here's another example of using fill flash to reduce the contrast. Plates **12-3** and **12-4** show a couple whose engagement session I did in Las Vegas. This part of the session was outside The Venetian.

The first image here was created using the natural light alone. The second image had fill flash to lift the shadow detail. I bounced the flash into the open ceiling and half behind me into the walls. Anyone who has been there knows how large a space it is, but enough light still bounced back from the walls and ceiling to lift the shadows and reduce the contrast. Note that I didn't use a flash modifier here. A flash modifier would have thrown too much light forward and made it *look* like flash was used, which quite often is ugly.

The difference is fairly subtle in the overall image when printed small—but in the enlarged images (plates **12-5** and **12-6**), you can certainly see the differ-

PLATE 12-3 (LEFT). This image was shot using the ambient light only.

PLATE 12-4 (RIGHT). Here, fill flash was used to lift the shadow detail. (SETTINGS: $^{1}/_{250}$ second, f/5, 400 ISO; FEC +0.3 EV)

PLATE 12-5. This is a cropped section of the image taken with no flash. In RAW conversion, the exposure was kept at 0 EV, and the same white balance correction was applied as in the previous image.

PLATE 12-6. This is a cropped section of the image as it came out of Canon's DPP (which follows the camera settings for image quality) with only a minor white-balance correction and the exposure pulled down −0.3 stops in RAW processing.

ence that adding flash made in the contrast. For me, the difference is pronounced. Plate **12-6** shows more detail, but the ambient-light mood is still retained; it certainly doesn't look like flash.

In this specific scenario, the most important setting was the shutter speed of ¹⁄₂₅₀ second (the maximum flash-sync speed for this camera). The other two settings, ISO and aperture, hinged on the choice of shutter speed. The reason for this is that I was working in bright conditions and wanted the most efficient use of my flash.

As mentioned earlier, using the maximum flash-sync speed offers us the widest possible aperture and the most range/output we can get from our speedlight. If we shoot at less than the maximum flash-sync speed, we're making our flashgun work harder than it probably needs to, because we are using a smaller aperture than we would have had to at the maximum flash-sync speed. (Again, we're thinking in terms of balancing flash with a very bright background or in bright conditions.) When we choose the most efficient settings, our batteries will last longer and the flashgun will recycle more quickly. Both of those things ensure that we will have more consistent exposures and be able to shoot faster.

For me, therefore, a ¹⁄₂₅₀ second shutter speed becomes an easy default when working outdoors. I have maximum efficiency from my flashgun (in case I need it), and at the slightly higher shutter speed I have less chance of camera shake or subject movement registering in the image.

> I have less chance of camera shake or subject movement registering in the image.

13. Controlling Light Falloff

Light falloff, which is how we describe the way that the light from your speedlight recedes to the background, is easily observed in photographs. We've all seen how people in the foreground are brighter than people in the background.

Not only can we easily see this in photos, but light falloff is one of those things that just make sense when we think about it—the further you move from a light source, the dimmer the light will be. When we use an on-camera flash, this means our backgrounds will become progressively darker as they recede into the distance. (For now, we're not looking at how ambient light will affect the appearance of the background. This is covered thoroughly in the section on dragging the shutter; see chapter 8.)

In more precise technical terms, light falloff is inversely proportional to the square of the change in distance between the subject and the light source. This means that if you move your subject twice as far from your light source, you will need four times more power from your light source to maintain the same lighting level on them. However, the exact math is not of overriding importance here; what's critical is understanding that light does indeed fall off as it travels away from the light source.

Right there we come to the crucial realization again: unless we are using direct flash (which should be avoided), we should not think of our light source as the speedlight itself but rather the area where the light is bounced from. Let's look at some examples.

Light falloff is one of those things that just make sense when we think about it.

Practical Examples

In the following sequence, I photographed a couple who were placed at different distances from the camera.

In the first image (plate **13-1**), I bounced flash behind me. This, of course, results in the male model being substantially darker than the female model. This is just logical: light falls off to the background and the background becomes darker. In this case, the light source was the wall behind me, and the male subject was quite a bit farther from it than the female subject.

If, instead, I place my light source at a point that is equidistant to both of them, I can light them up to the same brightness—or close enough. This we can

PLATE 13-1. When I bounced the flash into the wall behind me, the male subject was darker than the female subject because of falloff (he was farther from the light source than she was). (SETTINGS: $\frac{1}{250}$ second, f/4, 800 ISO; FEC +0.7 EV)

PLATE 13-2. Bouncing the flash off a point on the ceiling that was more or less equidistant to both subjects greatly reduced the issue of falloff. (SETTINGS: $\frac{1}{250}$ second, f/4, 800 ISO; FEC +0.7 EV)

PLATE 13-3. To show the ambient light levels, and indicate how much of our light is from the flash, here is an image of the same scene created using the ambient light only.

PLATE 13-4. The overall scene, showing the photographer in relation to the subjects.

> I also made sure to shield my flash from my subjects.

see in the next image (plate **13-2**), where I bounced flash forward and to the right of me at a point on the ceiling that was same distance to both of them. (*Note:* I also made sure to shield my flash from my subjects. Remember: anytime your subject can see your flash head or your flash diffuser, then you have direct flash. I used a piece of black foam to prevent any light from the flash from falling directly on them.) I should note that we have another advantage here: more directional light. This creates a more pleasing look than the flat light produced by bouncing the flash off the wall directly behind the camera.

The following are a few more examples of using this concept, controlling how bright our background will be—or how bright our subjects in the background will be—by controlling how we bounce our flash. All of these images had the flash gelled for tungsten with a ½ CTS gel to bring the color from the

PLATE 13-5. Bouncing the flash off an area equidistant to the subjects helps keep them evenly exposed. (SETTINGS: 1/60 second, f/4, 1600 ISO; FEC 0 EV; flash gelled with 1/2 CTS)

PLATE 13-6. Bouncing flash off an area of the ceiling equidistant to the subjects created even lighting. (SETTINGS: 1/60 second, f/4, 1600 ISO; FEC +0.3 EV; flash gelled with 1/2 CTS)

flash much closer to that of the tungsten available light. This also means there wasn't much change in color balance as the light from the flash receded toward the back.

For plate **13-5**, I shielded my flash from the bridesmaids by placing the black half-snoot on my speedlight. Then I directed the head of my flashgun away from me, toward a point on the ceiling that was more or less equidistant to everyone in the frame. As a result, everyone from the bridesmaid closest to me to the bridesmaid in the background is just about equally lit. There's no real need to dodge and burn in Photoshop—a real timesaver for your workflow.

At this wedding reception (plate **13-6**), I was able to use a single on-camera flash to light the wedding guests while they danced past me. If I had bounced my flash behind me, the guests closest to me would have been correctly ex-

Then I directed

the head of my flashgun

away from me . . .

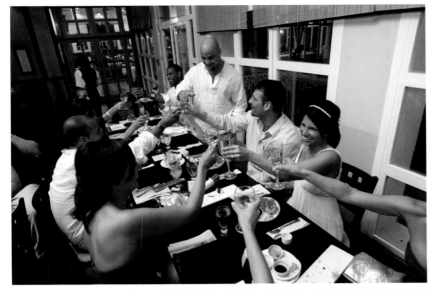

posed, with light falloff to the background causing the guests farther away from me to be less well exposed. Instead, I bounced my flash off a part of the ceiling equidistant to the people closest to me and the people dancing farther away from me.

This exact same technique was used to light up everyone in this table photograph (plate **13-7**). I used a single on-camera flash, bounced to my left and away from me, with the flash aimed at a part of the ceiling that was equidistant to everyone facing me at the table. This gives very even light from foreground to background without the need for additional lighting—or even a need to edit this image in Photoshop.

Approaching our bounce flash photography in this way, carefully thinking about the direction we want our light to come from, also means that our background and foreground can be evenly lit.

In this photograph of a cigar-roller (plate **13-8**), I bounced my flash off the far wall and part of the ceiling behind me. Because my light source was then quite distant in comparison to the distances of my foreground and background, they were evenly lit. There is no light falloff to the back in the photo. Aside from correction of the white balance, there was no other editing done to that image. No dodging and burning were necessary to get an even exposure from front to back, even though a wide-angle lens was used.

PLATE 13-9 (TOP). Using flash here, and using it with careful thought, gave me an image that needed very little adjustment. (SETTINGS: $1/80$ second, f/4, 1600 ISO; FEC +1.3 EV; flash gelled with $1/2$ CTS)

PLATE 13-10 (BOTTOM). Bouncing my flash to the side allowed me to light the bride and the groom equally well from just the single on-camera flash.

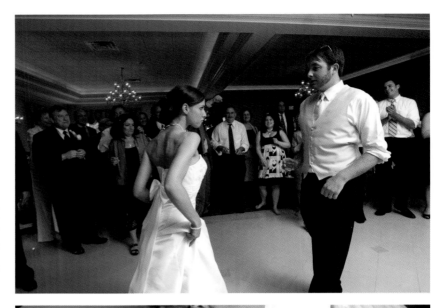

Using just a single light-source, an on-camera flash bounced to my right (and flagged with the black foam half-snoot), I was able to give directional light on this bride and groom dancing (plate **13-9**) and have enough light fall on the guests in the background. Only the white balance was corrected in this image; the exposure on the guests to the left in the image could still be brought up in Photoshop (I did not do this here in order to reveal the true effect of the flash).

Just to reiterate the point: we need to think of the area that we're bouncing our flash off as our light source. If we do this thoughtfully, placing the light source equidistant to our subjects (or subjects and background), they will be more evenly lit. This means we'll have better original captures that require less tweaking in postproduction.

14. Flash Techniques Outdoors

As much as the rest of the book deals with techniques to create soft directional light, when I photograph outdoors and only use my speedlight for fill flash, then I most often shoot with my speedlight straight-on with no diffuser or light modifier. However, there is a section later in this chapter that deals specifically with bounce flash techniques outdoors.

Fill Flash

Shooting with your on-camera flash in a straight-ahead position while indoors is possibly the worst way to use flash. We are far better off creating softer directional light by bouncing off a wall or other surface. This would be the ideal way to use flash outdoors, as well—and where I am able to, I do use off-camera lighting that is diffuse.

However, when I am working outside and only have my on-camera speedlight to help me with less-than-ideal available light (and I have specific limitations, such as not having an assistant to hold a reflector or not having a convenient nearby surface to bounce light off) then I accept the compromise of direct on-camera flash. Since I cannot bounce flash off the clouds—although I have seen photographers apparently try that, strangely enough—I accept that straight-on flash is all that I have at my disposal at the time.

When working with subjects outside, I will try to position them such that the ambient light is fairly even (or pleasant looking) on them. Then, I use fill flash to lift the shadow areas. In that case, I am using just a touch of fill flash and the flash is barely noticeable. Therefore, the fact that it is direct flash barely detracts from the overall image.

I rarely use a diffuser of any kind when I shoot outside with direct flash (as fill flash). The reason is that we only get softer light by creating a *much* larger light source. Using a generic light modifier on the front of the flash does *not* create a larger light source.

It is therefore just simpler to use the flash directly—straight-on and without a diffuser—and dial my flash compensation way down to around –2 or –3 EV. My initial metering is usually along the lines described earlier on in the book where I use a combination of the histogram and selective metering. I then check that there are no blinking highlights on my subject (*i.e.*, the relevant part of my

> I rarely use a diffuser of any kind when I shoot outside . . .

scene). Finally, I will also use the LCD preview image as a guide to whether my overall exposure is correct.

Practical Examples. For this portrait (plate **14-1**), I carefully placed my subjects in open shade and used undiffused, direct on-camera flash to lift the shadow areas just a touch. It does not look like direct flash because the flash was dialed way down and the flash exposure rides on top of the correct exposure for the available light (*i.e.,* the flash just sweetens the scene a bit).

For plate **14-2**, I made sure I had even light on my couple by having them turn away from the sunlight (*i.e.,* I placed my subjects in open shade). Similarly to the previous example, I used undiffused, direct on-camera flash to lift any shadow areas just a touch. Why did I choose –3 EV here and –2 EV in the previous example? The choice was based on what I saw in the preview image and my personal tastes for fill flash. Since the fill flash is well below the level of the available light, there is a fair amount of leeway in the actual flash exposure before it will have a dramatic effect on the image.

Since the flash is just a soft "touch" of fill flash, the exact value isn't of that great an importance; the flash just rides on top of correct ambient exposure. *That* is key here—that my available light exposure is correct. In both of these examples (and

PLATE 14-1 (TOP). At a low setting, the flash adds a subtle amount of fill. (SETTINGS: $^1/_{250}$ second, f/5, 500 ISO; on-camera TTL flash, FEC –2 EV)

PLATE 14-2 (BOTTOM). There's significant leeway when setting your fill flash; the setting you choose will depend largely on your personal tastes. (SETTINGS: $^1/_{320}$ second, f/4, 500 ISO; on-camera TTL flash, FEC –3 EV)

PLATE 14-3 (LEFT). Here is one more example to show that the great results you can achieve when using direct flash for fill-flash aren't merely flukes. (SETTINGS: ½₅₀ second, f/4, 800 ISO; on-camera TTL flash, FEC –3 EV)

PLATE 14-4 (RIGHT). High-speed flash sync made it possible to maintain the desired depth of field when adding fill flash to this scene. (SETTINGS: ¹⁄₁₀₀₀ second, f/4, 100 ISO; on-camera TTL flash, FEC –3 EV)

in every other example in this book), I shot in the manual exposure mode. It really is the only way to achieve consistent, correct exposure.

To create plate **14-4**, I used high-speed flash sync to maintain a shallow depth of field. I wanted the colorful backdrop of the quaint architecture in Oranjestad, Aruba, to give an interesting context to the photograph. However, I didn't want the detail in the wall's texture to pull attention away from the couple. The sun was bright and overhead, so I had to use flash to lift the shadows. I used direct flash, since there wasn't anywhere to bounce the flash off. I also needed to work fast, so the direct flash was the best possible option here.

Direct-Flash Main Light

Now, what about those times when flash isn't merely delicate fill light? As we've seen, using the speedlight for a touch of fill flash means that the direct flash is barely noticeable. However, if I have to use flash as a main source of light, then the flash is noticeable—but not necessarily objectionable.

PLATE 14-5. Here, using on-camera flash for the main light was an acceptable compromise to me because I needed to work quickly. (SETTINGS: $\frac{1}{250}$ second, f/7.1, 200 ISO; on-camera TTL flash, FEC +0.3 EV)

I'm of the opinion that using a flash modifier on the speedlight would barely have made a difference in the final appearance of plate **14-5**, since few flash modifiers offer a substantially larger light source over that of the speedlight's flash head. Using a modifier would only have hindered me by cutting down on my speedlight's power. Therefore, modifiers aren't generally of much use outdoors.

In plate **14-5** you can see that flash was used because there is a distinct flash shadow. I chose to accept that the flash shadow would be visible in this image, since lifting the shadow areas to match the brighter sunlit areas of the scene required more than just a hint of fill flash. This was an acceptable compromise for me since I was moving around a lot and needed to work quickly while getting good results.

So, yes, you can use direct on-camera flash when shooting outdoors and still get good results. However, it is still important to take care in how you use flash and, specifically, how you use flash in relation to the available light.

I chose to accept that the flash shadow would be visible in this image . . .

Bounce Flash

Many of the techniques described in this book are heavily dependent on shooting indoors, where there are places to bounce flash off. It wouldn't seem possible, then, to use these techniques outdoors—after all, you can't bounce flash off the clouds. Yet, while there are obvious limitations in applying these bounce-flash techniques outdoors, there are times when they can still be quite effective. Quite often, the simplest solution is just to have someone help you to hold up a reflector.

Practical Examples. Plate **14-6** is part of the portrait series I took of the bride and groom at their wedding in Aruba. The sun had already set, leaving the color of the light too cool. I had my assistant hold up a gold Lastolite reflector about eight feet behind me and I bounced my flash into that. This gave a lovely warm color to the flash, which mimicked the light from the setting sun of five minutes before. The shadow is more distinct, but still soft enough—and I think it looks natural in this scenario. I also made sure that the amount of flash would blend with the amount of ambient light left.

Similarly, to create plate **14-7**, an assistant held up a reflector to my right and I bounced an on-camera speedlight into it. This lifted the shadows and gave soft but directional light on the couple.

PLATE 14-6. Bouncing the flash into a gold reflector created lighting with a lovely, warm glow. (SETTINGS: ¹/₁₀₀ second, f/4, 640 ISO; on-camera TTL flash, FEC +0.3 EV)

PLATE 14-7. Bouncing flash into a reflector produced soft, directional light. (SET-TINGS: ¹/₁₂₅ second, f/5, 800 ISO; on-camera TTL flash, FEC –1.0 EV)

In plate **14-8**, the flash exposure compensation was set to 0 EV and the flash was bounced over my left shoulder into a reflector that an assistant was holding up. I metered for the evening sky and did a few test shots first to make sure that I was satisfied with the background exposure. Then I then positioned the model and switched my flash on.

However, you need not feel limited by not having an obvious area to bounce light off. In some cases, the reflector (and the assistant) aren't needed. Instead, you can bounce flash off of some less obvious surfaces. Have a look at plates **14-9** through **14-12**.

In plate **14-9**, I used the histogram method and calculated my exposure for the dress. This gave me nice skin tones but caused the evening sky to go completely white. The light from the lamp was also lost. By changing to a faster shutter speed and lower ISO settings (plate **14-10**), I got nice enough detail in the sky and the lamppost, but the couple was lost in murkiness.

Without changing my exposure settings, I turned the flash head 90 degrees to my left and bounced light into the shop displays (plate **14-11**). I didn't choose a particular surface; I just bounced flash off the buildings/windows/displays.

To see exactly what I was bouncing light from, look at plate **14-12**. This is a crop from another test shot, which shows the storefronts that the flash was bounced from. It was possible to get enough light bounced from those surfaces because only a touch of flash was needed to augment the available light. In this instance, enough light spilled back on my couple to enhance the final image.

As mentioned before, the exact settings of these images aren't important—what's critical is understanding *the method* of getting there. For the initial image in this sequence, we figured out the correct exposure for the couple using the histogram's display for the white dress. Nevertheless, as noted, the sky had no detail and the entire mood of the setting was lost. We needed to pull down our exposure to capture the mood.

We have three camera controls to affect the ambient exposure: shutter speed, aperture, and ISO. We could have changed any one, or two, or all three of those settings to give us a different exposure, showing more of the area where the

PLATE 14-8. Test shots were used to confirm the ambient light exposure of the background before moving the model into place and adding the flash. (SETTINGS: 1/30 second, f/3.5, 1250 ISO; on-camera TTL flash, FEC 0 EV)

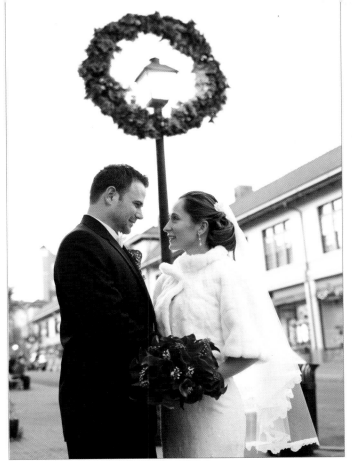

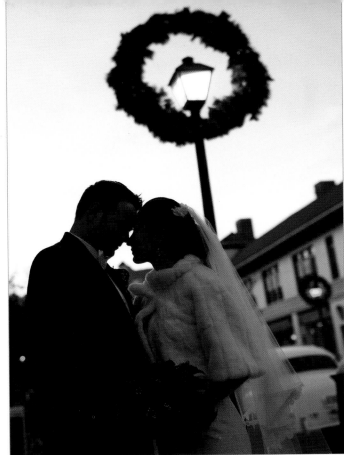

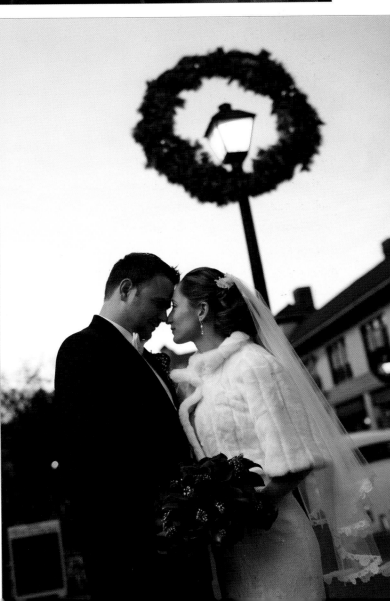

PLATE 14-9 (TOP LEFT). The nice evening light gave me a setting of ¹⁄₁₂₅ second at f/2 and 1000 ISO.

PLATE 14-10 (TOP RIGHT). Here, I changed my settings to ¹⁄₂₅₀ second at f/2 and 320 ISO.

PLATE 14-11 (RIGHT). With my exposure remaining at ¹⁄₂₅₀ second at f/2 and 320 ISO, I bounced flash at +2.0 EV into the store windows to my left.

PLATE 14-12 (ABOVE). This crop from another test shot shows the storefronts off which the flash was bounced.

couple was being photographed. In this instance, I decided to change the shutter speed first, which I set to the maximum flash-sync speed. The reason why I decided to change the shutter speed first is that shutter speed has no effect on the flash exposure (as long as it remains below the maximum sync speed).

I could then change either the aperture or ISO (or both) to bring down the ambient exposure more. This time I chose to change the ISO, and I simply dialed the ISO down by a few clicks. I didn't bring down the ISO to a specific value. Instead I simply flicked the dial of the camera by an undetermined number of clicks since all I needed was to bring the exposure down some more from our initial image.

I then checked the back of the LCD to see if the image looked satisfactory, and it did. This is how I ended up with 320 ISO. If the image on the LCD preview had been too light or too dark, I would have changed the ISO (and possibly the aperture) in a more controlled manner. However, doing it in this quick way gave me a good exposure.

Knowing your camera and having an understanding of the interrelation of your settings allows you to make this type of quick, on-the-fly adjustment and know that it will be acceptable. And, if needed, the leeway that the RAW file format gives you will help take up any slack in precise exposure when working fast.

I then took the next image, in which the couple was too dark, and finally brought some light onto them by bouncing the flash, as shown, into the storefronts nearby. This is the exact kind of opportunity where a touch of flash worked wonders.

> This is the exact kind of opportunity where a touch of flash worked wonders.

Controlling the Ambient Light to Flash Ratio

In plate **14-13**, part of the previous sequence with flash bounced off the storefronts, I noticed that there was some ambient light coming over his shoulder and falling on part of the bride's face. This resulted in uneven lighting.

I wanted to get rid of that without moving my couple around again—and I needed to work fast, so I changed my settings (plate **14-14**). The flash was TTL, therefore it would follow my settings (within what the flash unit was capable of giving). My objective was to drop the ambient light much lower and have the couple lit mostly by flash. I could do this by raising my shutter speed (which would have no effect on my flash output), or I could make my aperture smaller, or drop my ISO. I chose to do two of these three possibilities.

I immediately raised my shutter speed to the maximum flash-sync speed, giving me the most range from my flashgun. (See chapter 7 for the technical explanation why.) I then decided to drop my ISO by a stop to 320 ISO. I could just as well have closed down my aperture by a stop, or have changed both my aperture and ISO cumulatively by a stop.

By raising my shutter speed by more than a stop, and lowering my ISO by a stop, I managed to drop my ambient light by more than two stops. Since I was

PLATE 14-13 (TOP). At my initial settings, uneven lighting on the bride's face was apparent. This came from ambient light over the groom's shoulder. (SETTINGS: $\frac{1}{100}$ second, f/2, 640 ISO)

PLATE 14-14 (BOTTOM). Adjusting my camera settings dropped the ambient light and left the couple illuminated mostly by flash (addressing the problem of uneven lighting). (SETTINGS: $\frac{1}{100}$ second, f/2, 640 ISO)

using TTL flash, my camera and speedlight would follow my settings to still give me the correct exposure. You can see that the overall exposure on the couple didn't change by much, and that is because the TTL flash metering of my camera took care of that.

By dropping my ambient exposure by more than two stops, I made the uneven lighting on her face much less noticeable.

This quick and easy fix to a problem in my lighting was made possible by an understanding of how to balance shutter speed, aperture, and ISO settings—and the effect that changes to these settings would have on the ambient exposure and the flash exposure.

This example also clearly illustrates the benefit of digital technology. Because I was able to check the initial image on the back of my camera's LCD screen, I was able to correct for it on the go. This is hugely important in getting great results with flash—seeing the image on the LCD, analyzing it on the spot, and correcting for it without breaking your shooting rhythm.

Let's look at another example. In plate **14-15**, the camera settings show that I was really squeezing the last bit of light out of the area we were in, the garden outside the temple where the couple was about to get married. I wanted to shoot with a particular tree behind the couple. This tree still had its last remaining autumn leaves and was lit by a spotlight—but the evening light was also

I was really squeezing the last bit of light out of the area . . .

PLATE 14-15. It was already quite dark when I created this bounce-flash image. (SETTINGS: 1/100 second, f/1.2, 1250 ISO; FEC −1.0 EV)

PLATE 14-16 (TOP). This is another example from the same sequence see in plate **14-15** . (SETTINGS: $\frac{1}{125}$ second, f/1.2, 1250 ISO; FEC –2.0 EV)

PLATE 14-17 (BOTTOM). This is the same scene, photographed at the same camera settings, but with the ambient light only. (SETTINGS: $\frac{1}{125}$ second, f/1.2, 1250 ISO)

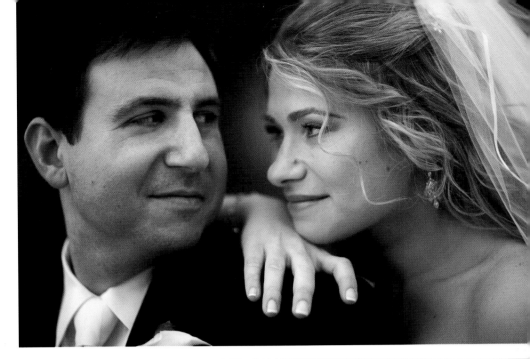

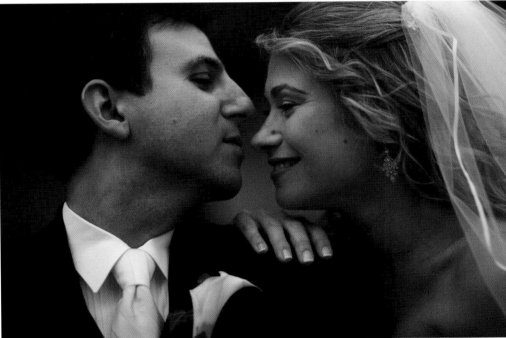

> To open up the shadows,
> I bounced flash off the
> brick wall of the temple.

coming from behind them, casting the couple's faces in shade. To open up the shadows on their faces, I bounced flash off the brick wall of the temple. Even though it was about thirty feet from where I was standing, enough light spilled back to register at a wide aperture and high ISO. Because the light from the flash came in from an angle, the foreground doesn't have that typical on-camera flash look to it.

Plate **14-16** is another image from the same sequence. Plate **14-17** is a comparison shot of the same scene to show the quality of the available light only. We could certainly correct the color balance as part of a regular postproduction raw workflow, but the flash opened the shadows and made the light more even on the subjects.

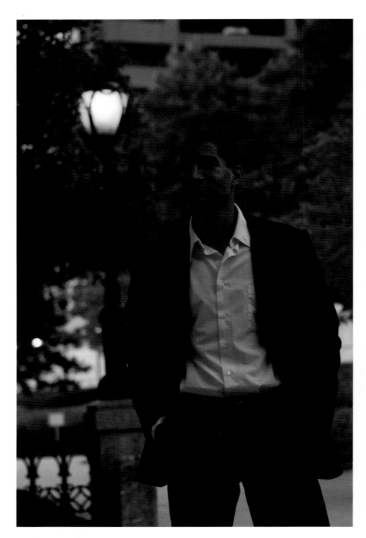

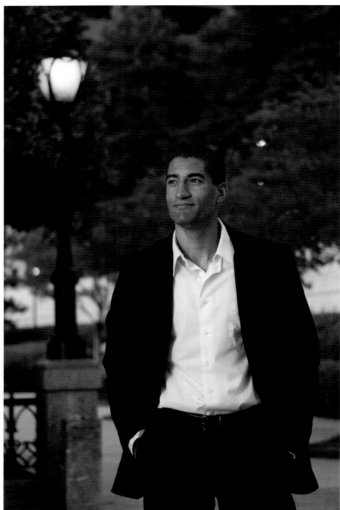

PLATE 14-18 (TOP LEFT). The setup photographed with ambient light only. (SETTINGS: ¹⁄₁₆₀ second, f/3.2, 800 ISO)

PLATE 14-19 (TOP RIGHT). The setup photographed with the addition of bounce flash. (SETTINGS: ¹⁄₁₆₀ second, f/3.2, 800 ISO; FEC +0.7 EV)

PLATE 14-20 (RIGHT). An overview of the area.

Plates **14-18** through **14-20**, a sequence of images created with a model, show the difference that flash makes in lifting the image from the background. In this scenario, I deliberately placed the model close to the side of the building in order to bounce flash off it to light the model. I shielded my flash from the model with a black-foam half-snoot, so there was no direct flash. With this setup, all of my light was soft and directional. This is a very simple setup and easily repeatable—all you need is a large area close to the subject to bounce the flash off. Here, the wide aperture and fairly high ISO helped get enough range out of the on-camera speedlight to sufficiently light the model. (*Note:* The flash wasn't filtered for these images.)

PLATE 14-21. A wide aperture softened the background and allowed me to bounce flash off a nearby building. (SETTINGS: $\frac{1}{100}$ second, f/3.2, 1000 ISO; FEC +1.0 EV)

PLATE 14-22. Here, the amount of flash in relation to the ambient light can clearly be seen. (SETTINGS: $\frac{1}{100}$ second, f/3.2, 1000 ISO)

PLATE 14-23. An overview of the scene.

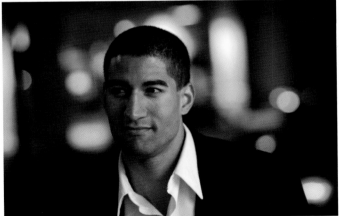

PLATE 14-24. By moving around a little bit, I can change the way the background looks and get subtle differences.

The above sequence (plates **14-21** to **14-24**) shows how I use the background to isolate my subject—and how this coordinates with my flash technique. Normally, I try to position my subject so that the background is either neutral, interesting, or somehow enhances the image. In this case, I used a telephoto zoom (70–200mm) with a wide aperture of f/3.2. This gave me a shallow depth of field—but more importantly, it gave me an aperture that allowed me to bounce flash off the building behind me and to my right-hand side.

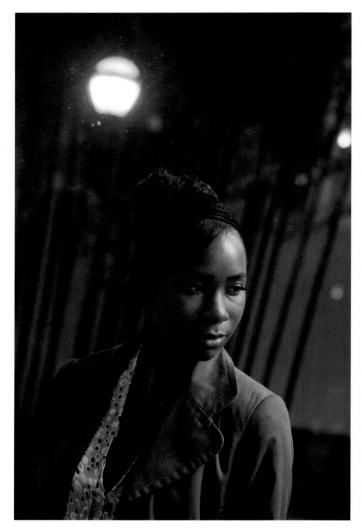

PLATE 14-25 (TOP LEFT). Flash was bounced off a pillar to the side of the camera to light the model. (SETTINGS: $\frac{1}{50}$ second, f/3.2, 800 ISO; FEC +1.0 EV)

PLATE 14-26 (TOP RIGHT). Here, no flash was used, giving you a clear idea of how the flash affected the look of the photograph and enhanced the portrait of my model. (SETTINGS: $\frac{1}{50}$ second, f/3.2, 800 ISO)

PLATE 14-27 (RIGHT). The relative positioning of the model, the camera, and the area that I bounced my flash off (the pillar to my side) can be seen.

Plates **14-25** through **14-27** show another scenario where I was looking for an interesting backdrop to photograph my model against—and still keeping in mind possible ways to use my on-camera speedlight to enhance the lighting. In this case, a window display of a business in the downtown area worked as a backdrop, creating an enigmatic feel. The reflection in the window of the streetlamp behind me just added to the look of the image. I then positioned my model in a way that the light I was bouncing off a pillar to the side of me would fall onto her face, creating a dramatic look.

PLATE 14-28 (TOP LEFT). The wide aperture and high ISO setting made it possible to bounce flash off a wall that was relatively far from the subjects. (SETTINGS: $\frac{1}{160}$ second, f/2.8, 800 ISO; FEC +1.7 EV)

PLATE 14-29 (TOP RIGHT). The same scene shot with the ambient light only. (SETTINGS: $\frac{1}{160}$ second, f/2.8, 800 ISO)

PLATE 14-30 (LEFT). An overview of the scene showing the camera, the subjects, and the wall off which flash was bounced.

In the next illustrative sequence (plates **14-28** through **14-30**), I placed my couple so that I could use the out-of-focus trees as a soft background. I then used flash, bounced off the side of the building, to light them better than the available light did. By bouncing my flash off the side of that building, I created light that fell on the subjects from an angle—far more flattering than light directly from the front. In this case, I also gelled my flash with a ½ CTS filter to give a warm tone to the light. The evening light was already becoming low, so it necessitated settings on my camera that would allow available light to register ($\frac{1}{160}$ second at f/2.8 and 800 ISO). This also worked in my favor by mak-

PLATE 14-31 (TOP LEFT). This is a fairly extreme case of bounce flash. Maximizing the flash output was critical to achieving success. (SETTINGS: ⅟₁₂₅ second, f/2.8, 800 ISO; flash in manual)

PLATE 14-32 (TOP RIGHT). The same scene and subject photographed with available light only. (SETTINGS: ⅟₁₂₅ second, f/2.8, 800 ISO)

PLATE 14-33 RIGHT). A setup shot showing the position of the camera, model, and the wall off which the flash was bounced.

ing it possible to bounce flash off a wall that was relatively far from my subjects. At such a wide aperture and high an ISO, the flash will easily register.

Plates **14-31** through **14-33** show a fairly extreme example of bouncing the light from the flash—all in an effort to enhance the available light. The light from the flash opened up the shadows and created a more flattering light than just the available light alone would have done. To make sure that I got the absolute maximum output from my flash (an attempt to get enough light from the speedlight to cover the large distance) I put my flash in manual mode here. Additionally, choosing a wide aperture not only helped isolate the model from the background; in this case it was also essential to getting enough light from the flashgun to bounce back from that high wall.

PLATE 14-34 (RIGHT). Flash was bounced off a business sign to create this image. (SETTINGS: $1/100$ second, f/2.8, 800 ISO; flash in manual)

PLATE 14-35 (ABOVE). An overview of the setup.

I was not particularly concerned about any color cast that would be introduced . . .

Plate **14-34** is another example illustrating how carefully placing a couple in relation to an interesting background and then using bounce flash can create a flattering portrait. In this instance, I used the colorful lights in the window display of this business's office front, then bounced flash off their sign outside. (*Note:* I was not particularly concerned about any color cast that would be introduced by the business sign that I bounced my flash off; a slight color cast is easily corrected as part of a RAW workflow and it gave me pleasant skin tones.)

As you've seen in the examples in this section, I often position my subjects specifically so that I can use nearby surfaces to bounce light off. If there isn't a surface immediately available, I look for one and then work within those limitations. With some thought and ingenuity, we are quite often able to adapt to a specific situation and create interesting light with our on-camera flashgun— or even just enhance the available light in a subtle way.

Dealing with Hard Sunlight

Hard sunlight is one of the toughest lighting conditions to deal with. Where I can, I try to position my subjects so that they are in shade or, at the very least, with their backs to the sun. This way, they are looking away from the bright light and less likely to squint and frown. They will also have more even shaded light on their faces, with rim lighting around the sides.

In situations where you cannot position people as you'd like and have to deal with the lighting situation as it is, you have a few options. The following examples assume that you are a solo photographer without a team of assistants to hold up large scrims and fill lights. In this case, you have to make do with what you have: a camera with a speedlight mounted on it.

In hard sunlight, you can get lucky with the angle so the features and details of most of the people are shaded, providing you with fairly uniform light on the essential parts of what you want to capture. Some parts of the scene will blow out, but hopefully nothing really relevant will be lost. In plate **14-36**, no flash was used. However, I did work things in my favor by shooting in the RAW format so that I would have much more control over the image in postproduction. This allowed me to more easily hold detail in the highlights while bringing up detail in the shadow areas.

If you are stuck with full sun where part of the subject is in shade and the rest in sun, you have two options: use flash or don't use flash. Let's look at a couple of examples.

In plate **14-37**, I used direct flash with no light modifier. I would suggest staying at the maximum flash-sync speed to get the most range/power from your flashgun. Only go to high-speed sync flash if you really need that shallow depth of field or a high shutter speed. Here, I used the histogram to make sure I didn't lose detail in the highlights, and then I added flash at –0.7 EV com-

> This allowed me to more easily hold detail in the highlights . . .

PLATE 14-36. Shooting in the RAW mode gave me the greatest postproduction options for this image shot in hard sunlight. (SETTINGS: $\frac{1}{640}$ second, f/4, 200 ISO)

PLATE 14-37. Adding flash at FEC –0.7 EV made for an image that needed no work in postproduction. (SETTINGS: ¹⁄₃₀₀ second, f/9, 100 ISO; FEC –0.7 EV)

PLATE 14-38. Harsh contrast and a lack of shadow detail make this a poor image.

PLATE 14-39. Postproduction enhancements can rescue no-flash images made in hard sunlight—but these corrections take time.

I would be quite happy to accept the compromise of fairly hard fill flash . . .

pensation. The flash, in this instance, is more than just a subtle fill flash so I had to dial it up from my usual fill-flash range of –3 to –2 EV. This image needed no work in postproduction to look like this. As far as I am concerned, it is a perfectly acceptable image of these two flower girls.

Then you have another option: don't use flash. If you take this approach, you will have to accept that one of two things will happen. The first possibility is that the image is going to look poor because of a lack of shadow detail and because of the harsh contrast (plate **14-38**). Or you can accept that the image without flash is going to need some work in Photoshop. To create plate **14-39**, I made two JPGs from the RAW file, each at different exposures. Then I combined the two JPGs as layers in Photoshop and masked off certain areas so I could get detail in the shadows and retain detail in the highlights. The result does look good, but doing it this way definitely takes some time.

So there you have the choices. Personally, I would be quite happy to accept the compromise of fairly hard fill flash to bring up the shadow detail in this situation. Doing it this way, and still controlling my exposure properly by using my camera in the manual exposure mode, gives me a very good image at the actual moment of taking the photograph. This greatly reduces the time I'll need to spend on the image in postproduction.

Dealing with Overhead Sunlight

This next illustrative sequence will show the simple options available when working in hard overhead sun.

PLATE 14-40. Bright overhead lighting creates unflattering hot-spots on the subject's face. (SETTINGS: 1/640 second, f/3.5, 100 ISO)

PLATE 14-41. Turning the model's face away from the sun creates much better lighting on her face, although some detail is now lost on her hair. (SETTINGS: 1/250 second, f/4, 125 ISO)

PLATE 14-42. Dropping the ambient-light exposure and adding flash results in a balanced exposure. (SETTINGS: 1/250 second, f/6.3, 100 ISO; FEC –1.0 EV)

Plate **14-40** is typical of how harsh overhead sunlight looks in a simple portrait, with various areas of the face blowing out. Even using flash wouldn't help much, unless the ambient exposure was pulled down considerably and the portrait then lit with flash. Even doing it this way with on-camera flash rarely looks good.

Simply repositioning my model (plate **14-41**) caused her face to become entirely shaded. Even though we're losing detail in her hair, the light on her face is now far more pleasing and soft.

Getting more detail in the sunlit area of her hair would mean pulling down the ambient exposure, then just using some fill flash to brighten up her face. Plate **14-42** shows nearly two stops difference in the available-light exposure compared to the previous image, so the flash was needed here to make sure her face wasn't underexposed.

My personal preference here would be for the second image in the sequence, where no flash was used. To me, the loss of detail on her hair is acceptable as a compromise for working in harsh light like this. (*Note:* Having an assistant hold up a scrim to block the light would give better results still.)

Even using flash wouldn't help much, unless the ambient exposure was pulled down considerably.

15. Off-Camera Wireless TTL Flash

As much as an on-camera speedlight will give us speed and flexibility if used with some thought, there is only so much you can do when your speedlight is mounted on your camera. Even though you can bounce light off all kinds of surfaces, sometimes to a surprising degree of effectiveness, it opens a whole new world when you move your lighting off the camera. Off-camera lighting falls beyond the scope of this book, but I would like to briefly touch on the topic here as an indication of the possibilities this technique offers.

Controlling an off-camera wireless flash can be done via a few methods. These include using another speedlight as the master to control a second, slaved speedlight; or using a dedicated control unit, such as the Canon ST-E2 or Nikon SU-800; or using the Radio Poppers. Specific details on how to set them up will depend on the particular unit; check the owners's manual for details.

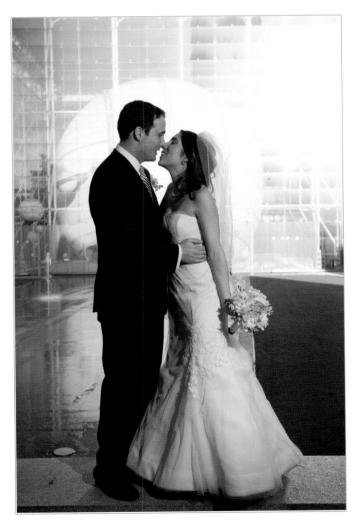

Let's look at some examples of using off-camera flash—and the results that can be achieved.

To create plate **15-1**, I had my assistant hold a slaved speedlight up high to my right. Notice the high shutter speed, which was close to the maximum flash-sync speed of $\frac{1}{300}$ second on this camera. The exposure was calculated by looking at the LCD preview before I set up the couple. I simply found an exposure where the brightest part of the sun's reflection in the glass building was barely blowing out with no detail. I intentionally chose my exposure so that the hot spot from the sun's reflection remained, instead of muting it by bringing my exposure down some more. This is the specific mood I wanted to retain in this image. I used the off-camera TTL flash as directional lighting on the couple. Having the flash off-camera gave more form to the dress than if I had used hard, direct, on-camera flash.

PLATE 15-1. The slaved speedlight was held up high in the hand of my assistant, who was standing to my right. She pointed the speedlight directly at the couple. (SETTINGS: $\frac{1}{250}$ second, f/5.0, 100 ISO; FEC +0.7 EV)

PLATE 15-2. My assistant held a camera with a slaved speedlight, positioning it to create bounce light on the bride when triggered by my own camera. (SETTINGS: $\frac{1}{100}$ second, f/5.0, 500 ISO; FEC +0.3 EV)

When creating plate **15-2**, I first tried a test shot, bouncing my flash to my right behind me. The result looked flat and I wasn't happy with the way the wall was blown out in the mirror. Fortunately, I keep two cameras on me at all times, each with a speedlight attached. Either of those speedlights is ready to be used as a master or slave. In this instance, I had my assistant stand in the corner away from the bride and me. He pointed the flash (still on the camera) toward the wall and ceiling in front and to the left of the bride. I disabled the output from my own camera's speedlight, but allowed it to trigger the slaved speedlight that my assistant was holding. The resulting image was softly and evenly lit, with no blown-out areas in the mirror. (*Note:* Check your specific flashgun's manual to

Either of those speedlights is ready to be used as a master or slave.

learn how to disable the output from the master flash while still allowing it to trigger a slaved flashgun.)

I often vary how I set up additional lighting at reception venues. In plates **15-3** and **15-4**, I had a flashgun that I held up high in my left hand. This was triggered by an on-camera wireless TTL flash controller (a Canon ST-E2 in this case; Nikon makes a similar unit, the SU-800). I also had a second flashgun that was wirelessly slaved via the controller/transmitter. This flashgun was placed on the DJ's speakers and angled up. Using these tools, I could then control my viewpoint and perspective—for example, using the second flashgun to throw light on the background, giving some sense of depth. This helped avoid that dreaded "black-hole" background.

> This flashgun was placed on the DJ's speakers and angled up.

Compare the two images, both shot with the two TTL wireless-controlled flashguns. In the first image (plate **15-3**), I shot at a 90-degree angle to the second flashgun. As a result, there is a cross-lighting effect in the background. In the second image (plate **15-4**), I shot in the same direction as the second flashgun. This gave me a lot of light, but it recedes to the background, which then progressively becomes darker.

In plates **15-3** and **15-4**, there was no wall behind me to bounce flash off—just the rest of the reception room. Because the ceiling was low, the light is not as spread out as I would have liked. The way the light in the background is concentrated is a result of the flash being bounced off a low ceiling, and not because it was direct flash.

The flash held in my left hand was also fitted with a Stofen Omnibounce with the top cut off (as shown in plate **9-12**. This way, I could still direct my light to a certain extent. With my hand, I could also cover part of the front of the Omnibounce and have less direct light if I wanted.

I adapt my technique from wedding to wedding, depending on the venue, the ambient light sources, and the results I want.

PLATE 15-3 (TOP). Shooting at an angle to the slaved flash in the background created a cross-lighting effect. (SETTINGS: $\frac{1}{125}$ second, f/2.8, 1600 ISO)

PLATE 15-4 (BOTTOM). Shooting in the same direction as the slaved flash in the background let the background go progressively darker. (SETTINGS: $\frac{1}{20}$ second, f/4, 800 ISO)

16. Off-Camera Manual Flash

Taking off-camera lighting a step further, my light on the couple in plate **16-1** was from two speedlights, each in a softbox mounted on a monopod. My assistant held both monopods, pointing one at each subject in the image. The original exposure was based on the sky, and then the flash was added and balanced with the ambient exposure of the sky to create this dramatic effect.

This kind of lighting effect is hard to achieve without taking the speedlight completely off-camera and allowing you as the photographer, the freedom to move independently from the light source.

Calculating Exposure

I would like to go over the method to calculate the exposure in this instance; it ties up several ideas from the rest of the book. Since I was using manual flash, there were four factors controlling the flash exposure. The first factor was the power setting on the flash. I kept this at half power, so the recycling would be fast enough.

The second factor was the distance to the subject. Since the flash was in a softbox held aloft on a monopod by someone else, the other person could help control the exposure by bringing the softbox closer or further away on instruction of the photographer. At this point, this is the one variable with which we can control the flash exposure independently from the ambient light.

The third and fourth factors are ISO and aperture. The sky was still fairly bright, therefore a setting of 100 ISO made most sense. (*Note:* The actual ISO could have been higher if I needed more depth of field. Since the ISO setting affects both the ambient and the flash exposure, any ISO would have been okay as long as we didn't run out of possible apertures to use.) Next, an appropriate aperture was chosen to expose for the sky. In the case of plate **16-1**, I chose to create a dramatic sky by underexposing slightly. We've now established the desired ambient exposure. Then, the softbox was held close enough—or far enough—for the proper flash exposure on the subjects (*i.e.,* we controlled the distance between the flash and the subjects).

Let's consider the decision to go to the maximum flash-sync speed, though. As noted on the previous pages, shutter speed controls the ambient light and has no direct effect on flash exposure. However, when you work in bright con-

Since I was using manual flash, there were four factors controlling the flash exposure.

ditions, the maximum flash-sync speed is hugely important. Think about it this way: You want more range on your flashgun, since you rarely want to work right up close to your subject (at the least, you don't want to be *forced* to work right up close). Therefore, you need more distance/range on your flash. This implies that you need a wider aperture. Since your ambient light is constant, you have a whole range of shutter speed/aperture combinations to work at. However, your flash is going to have a harder time trying to dump enough light at f/22 than it would have at f/16, or f/11. Similarly, your flash has an easier time with f/5.6 than f/8. Then you hit the ceiling at the maximum flash-sync speed. Over that, you go into high-speed sync mode, and your flash's output drops considerably. So you have a sweet spot at the maximum flash-sync speed.

Therefore, when you work in bright conditions, you might as well just go to the maximum flash-sync speed immediately, since this is where you will have your widest aperture and, hence, the most range/distance from your flashgun. This is crucial to understanding how to balance flash with daylight. It becomes an easy shortcut: Bright conditions? Then immediately go to the maximum flash-sync speed. You might as well also go to 100 ISO. Then, find your aperture for the correct ambient exposure at these other two settings. Finally, find your correct (manual) flash exposure. You're done—and it was easy because you immediately went to the maximum flash-sync speed.

PLATE 16-1. Two speedlights were placed in softboxes mounted on monopods and held by an assistant, who pointed them toward the subjects. (SETTINGS: ½₅₀ second, f/5, 100 ISO)

Afterword

It is sometimes said that certain subjects remain difficult until you grasp them and internalize them to the point where you don't have to really "think" about them. That's when those subjects become much easier. I suspect the same is true of flash photography.

At the start of the book, I mentioned that I believe that lighting and flash photography can at a certain level be fairly intuitive these days with digital photography. I hope that the concepts you've read about here will help you to develop that intuitive feel, backed by solid technique.

In this book (as on my web site, www.planetneil.com), I have tried to pass along the fundamentals of flash photography. Perhaps in doing so, I have encouraged you to think about some concepts and techniques that you might not have considered before—and to practice them until they become second nature. However, I also often give the advice to newer photographers not to over-think their approach to flash in terms of their technique, and also not get caught up in the nuts and bolts of the equipment.

In that sense, I hope you will also make it a habit to first consider the results you want to achieve—to look, anticipate, and adjust. In other words, "feel" what you want to achieve and then fluidly adapt your technique toward that. Ultimately, everything we do should be results-based, focusing on two basic questions: How good do our images look? What can we do to improve them?

I hope this book has helped you to answer those questions and achieve the images you want to create.

Resources

www.dg28.com/technique.html—Neil Turner
www.strobist.blogspot.com—Strobist (David Hobby's website on lighting)
www.onelightworkshop.com—Zack Arias
www.daveblackphotography.com—Dave Black
www.abetterbouncecard.com—Peter Gregg
www.filmlessphotos.ca—John Lehmann
makelightreal.com—Neil Cowley

And, of course: www.planetneil.com/tangents/

Index

50 LIGHTING SETUP FOR PORTRAIT PHOTOGRAPHERS

Steven H. Begleiter

Filled with unique portraits and lighting diagrams, plus the "recipe" for creating each one, this book is an indispensible resource you'll rely on for a wide range of portrait situations and subjects. $34.95 list, 8.5x11, 128p, 150 color images and diagrams, index, order no. 1872.

DIGITAL PHOTOGRAPHY BOOT CAMP, 2nd Ed.

Kevin Kubota

This popular book based on Kevin Kubota's sell-out workshop series is now fully updated with techniques for Adobe Photoshop and Lightroom. It's a down-and-dirty, step-by-step course for professionals! $34.95 list, 8.5x11, 128p, 220 color images, index, order no. 1873.

100 TECHNIQUES FOR PROFESSIONAL WEDDING PHOTOGRAPHERS

Bill Hurter

Top photographers provide tips for becoming a better shooter—from optimizing your gear, to capturing perfect moments, to streamlining your workflow. $34.95 list, 8.5x11, 128p, 180 color images and diagrams, index, order no. 1875.

500 POSES FOR PHOTOGRAPHING WOMEN

Michelle Perkins

A vast assortment of inspiring images, from head-and-shoulders to full-length portrsits, and classic to contemporary styles—perfect for when you need a little shot of inspiration to create a new pose. $34.95 list, 8.5x11, 128p, 500 color images, index, order no. 1879.

POWER MARKETING, SELLING, AND PRICING

A BUSINESS GUIDE FOR WEDDING AND PORTRAIT PHOTOGRAPHERS, 2ND ED.

Mitche Graf

Master the skills you need to take control of your business, boost your bottom line, and build the life you want. $34.95 list, 8.5x11, 144p, 90 color images, index, order no. 1876.

SCULPTING WITH LIGHT

Allison Earnest

Learn how to design the lighting effect that will best flatter your subject. Studio and location lighting setups are covered in detail with an assortment of helpful variations provided for each shot. $34.95 list, 8.5x11, 128p, 175 color images, diagrams, index, order no. 1867.

MINIMALIST LIGHTING

PROFESSIONAL TECHNIQUES FOR LOCATION PHOTOGRAPHY

Kirk Tuck

Use small, computerized, battery-operated flash units and lightweight accessories to get the top-quality results you want on location! $34.95 list, 8.5x11, 128p, 175 color images and diagrams, index, order no. 1860.

JEFF SMITH'S POSING TECHNIQUES FOR LOCATION PORTRAIT PHOTOGRAPHY

Use architectural and natural elements to support the pose, maximize the flow of the session, and create refined, artful poses for individual subjects and groups—indoors or out. $34.95 list, 8.5x11, 128p, 150 color photos, index, order no. 1851.

MASTER LIGHTING GUIDE

FOR WEDDING PHOTOGRAPHERS

Bill Hurter

Capture perfect lighting quickly and easily at the ceremony and reception—indoors and out. Includes tips from the pros for lighting individuals, couples, and groups. $34.95 list, 8.5x11, 128p, 200 color photos, index, order no. 1852.

THE BEST OF PHOTOGRAPHIC LIGHTING 2nd Ed.

Bill Hurter

Top pros reveal the secrets behind their studio, location, and outdoor lighting strategies. Packed with tips for portraits, still lifes, and more. $34.95 list, 8.5x11, 128p, 200 color photos, index, order no. 1849.

PROFESSIONAL PORTRAIT POSING
TECHNIQUES AND IMAGES FROM MASTER PHOTOGRAPHERS

Michelle Perkins

Learn how master photographers pose subjects to create unforgettable images. $34.95 list, 8.5x11, 128p, 175 color images, index, order no. 2002.

SOFTBOX LIGHTING TECHNIQUES
FOR PROFESSIONAL PHOTOGRAPHERS

Stephen A. Dantzig

Learn to use one of photography's most popular lighting devices to produce soft and flawless effects for portraits, product shots, and more. $34.95 list, 8.5x11, 128p, 260 color images, index, order no. 1839.

BEGINNER'S GUIDE TO PHOTOGRAPHIC LIGHTING

Don Marr

Create high-impact photographs of any subject with Marr's simple techniques. From edgy and dynamic to subdued and natural, this book will show you how to get the myriad effects you're after. $34.95 list, 8.5x11, 128p, 150 color photos, index, order no. 1785.

JEFF SMITH'S LIGHTING FOR OUTDOOR AND LOCATION PORTRAIT PHOTOGRAPHY

Learn how to use light throughout the day—indoors and out—and make location portraits a highly profitable venture for your studio. $34.95 list, 8.5x11, 128p, 170 color images, index, order no. 1841.

STUDIO PORTRAIT PHOTOGRAPHY OF CHILDREN AND BABIES, 3rd Ed.

Marilyn Sholin

Work with the youngest portrait clients to create cherished images. Includes techniques for working with kids at every developmental stage, from infant to preschooler. $34.95 list, 8.5x11, 128p, 140 color photos, order no. 1845.

MONTE ZUCKER'S PORTRAIT PHOTOGRAPHY HANDBOOK

Acclaimed portrait photographer Monte Zucker takes you behind the scenes and shows you how to create a "Monte Portrait." Covers techniques for both studio and location shoots. $34.95 list, 8.5x11, 128p, 200 color photos, index, order no. 1846.

EXISTING LIGHT
TECHNIQUES FOR WEDDING AND PORTRAIT PHOTOGRAPHY

Bill Hurter

Learn to work with window light, make the most of outdoor light, and use fluorescent and incandescent light to best effect. $34.95 list, 8.5x11, 128p, 150 color photos, index, order no. 1858.

PROFESSIONAL PORTRAIT LIGHTING
TECHNIQUES AND IMAGES FROM MASTER PHOTOGRAPHERS

Michelle Perkins

Get a behind-the-scenes look at the lighting techniques employed by the world's top portrait photographers. $34.95 list, 8.5x11, 128p, 200 color photos, index, order no. 2000.

MASTER LIGHTING GUIDE
FOR PORTRAIT PHOTOGRAPHERS

Christopher Grey

Efficiently light executive and model portraits, high and low key images, and more. Master traditional lighting styles and use creative modi-fications that will maximize your results. $29.95 list, 8.5x11, 128p, 300 color photos, index, order no. 1778.